THE ART POTTERY OF JOSEPH MRAZEK

By

Robert J. Mrazek and Harold R. Mrazek

WingSpan Press

Copyright © 2009 by Robert J. Mrazek
All rights reserved.

No part of this book may be reproduced or transmitted in any form or by any means, electronic or mechanical, including photocopying, recording or by any information storage and retrieval system, without written permission from the author, except for the inclusion of brief quotations in review.

Printed in the United States of America

Published by WingSpan Press, Livermore, CA
www.wingspanpress.com

The WingSpan name, logo and colophon are the trademarks of WingSpan Publishing.

ISBN 978-1-59594-329-3
First edition 2009

Library of Congress Control Number 2009937824

To Jim, Ann, Kim, Chris,
Susannah, James, Carolyn, and the
rest of the Mrazek clan

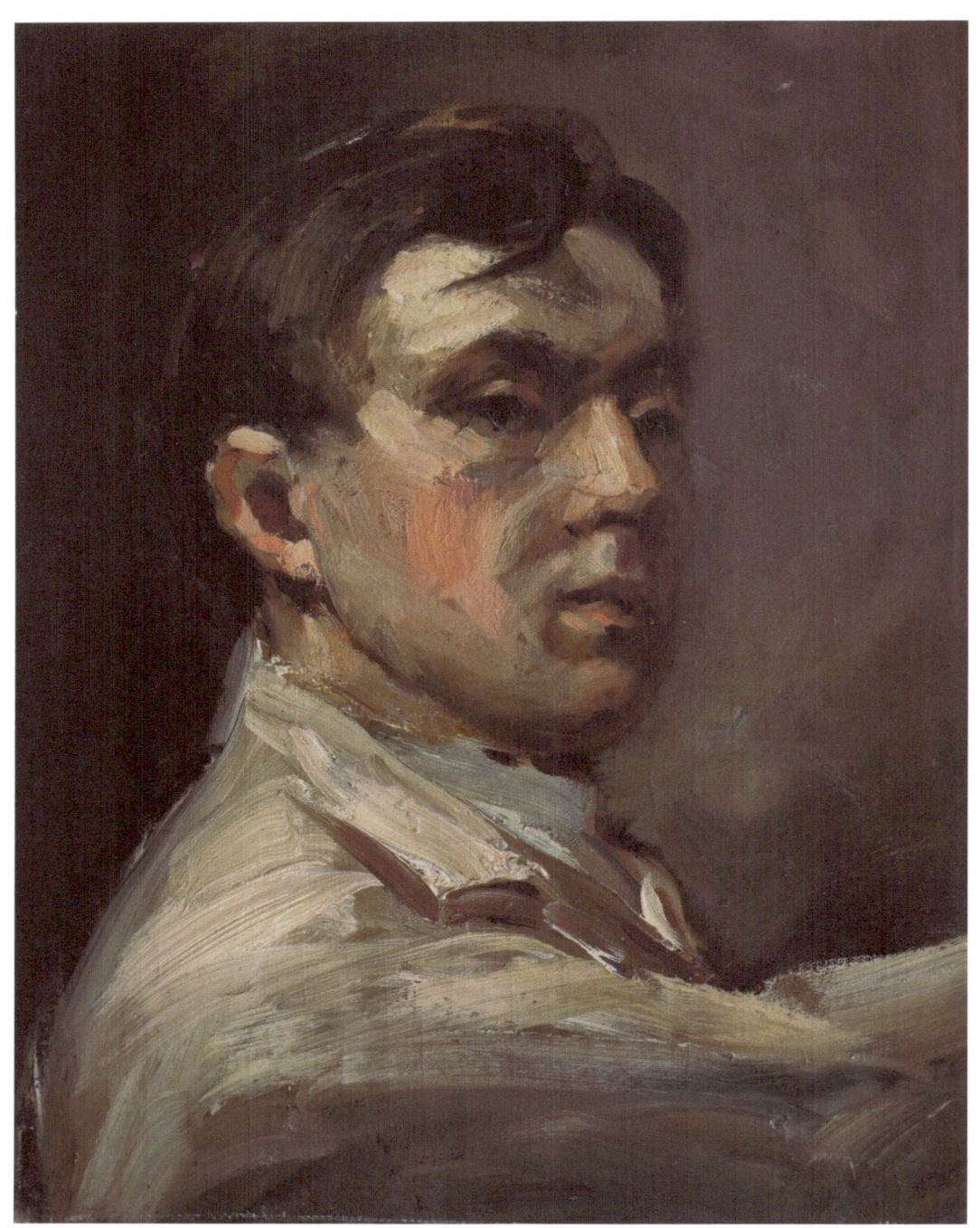

A Self-portrait of Joseph Mrazek (Oil, 1917)

Foreword

By any measure, Joseph Mrazek was an extraordinary man.

Born in 1889 in Bohemia, now part of the Czech Republic, he died at the age of sixty-nine in Huntington, New York. During the course of his adventurous life, he became a gifted painter and muralist, a decorated hero of the Czechoslovakian independence movement, an American undercover agent in World War I, and a friend of Tomas Masaryk, the "father of Czechoslovakia."

Between the two world wars, he was the largest producer of hand-painted pottery in Czechoslovakia, most of which was exported to the United States. A pioneer in plastics development, he was recruited in the late 1930's by two leading New York stage designers, Harry Horner and Boris Aronson, to fabricate new, lightweight plastic stage sets for some of the most successful shows in the history of Broadway and Radio City Music Hall. With the advent of the Second World War, he invented and manufactured a critically important military aircraft component that was integrated into more than 70,000 U.S. warplanes.

Perhaps Joseph Mrazek's most enduring legacy can be found in the brilliantly-colored, hand-painted pottery that he created from 1918-1933. The pieces remain as dramatic and vibrant today as when he first put brush to clay, retaining a brightness and durability that is astonishing.

His pottery designs were quickly embraced by the most exclusive department stores in the United States, and Joseph Mrazek's pottery was sold as quickly as soon as it could be produced, eventually gracing the dining tables of many of the nation's first families.

Some years ago, the author was given a tour of Ernest Hemingway's home in Key West, Florida, and was thrilled to see a set of Joseph Mrazek's cubist pottery prominently displayed in the Hemingway kitchen.

Today, his pottery can also be found in museum collections and in the homes of thousands of collectors all over the world. This book, which was written together with my father, the late Harold Mrazek, is dedicated to providing a greater awareness and insight into Joseph Mrazek's legacy and his equally colorful life.

Robert J. Mrazek (2009)

A Journey Begun

Joseph Mrazek was born on December 29, 1889, in Podebrady, Bohemia, a medieval town located thirty miles east of Prague along the Elbe River. Like the rest of ancient Bohemia, it had long been part of the Austro-Hungarian Empire.

Joseph Mrazek was one of six children. His parents managed a theatrical troupe that toured the small towns of Bohemia and Moravia, carrying scenery, costumes and props in gypsy wagons, and putting on a repertoire that ranged from Shakespeare and Moliere to Czech romantic comedies and Jules Verne. From an early age, Joseph developed a love for theater and stagecraft, particularly the ability to create a make believe world from an empty space.

During his last two years of compulsory schooling, Joseph was apprenticed to an accomplished artist in Podebrady. After learning to paint in the mediums of oil, pastel, and watercolor, Joseph demonstrated a natural gift for form and color, particularly excelling at oil painting. Under the tutelage of the master painter, he was commissioned to create murals in regional churches, restaurants, and social clubs. His apprenticeship continued until the age of seventeen, when he earned his journeyman's license as a trained artist.

By then, he had grown into a powerfully-built young man, with a barrel chest, slender waist, and open, intelligent face. A talented gymnast, he won numerous prizes at club competitions sponsored by the Sokol movement, which was dedicated to providing Czech and Slovak youth with opportunities for physical training and athletic contests.

Joseph's parents were bitterly opposed to the centuries-long subjugation of the Czech and Slovak people by the Hapsburg monarchy of the Austro-Hungarian Empire, and from an early age he came to share their views. Like many young Czechs, he dreamed of going to the United States, where he had read that a man was free to pursue his dreams without interference from the dictates of petty princes and ancient conflicts, where one was judged only on his talent and hard work, not on an anointed bloodline.

One of Joseph Mrazek's uncles had emigrated to the United States in the 1870's, and had eventually saved

enough money to buy a small farm in Yankton, South Dakota. In 1908, he wrote to Joseph and told him that he would pay for his passage to South Dakota if Joseph promised to work on his farm until the debt was repaid. He gladly agreed.

Speaking no English at the time, he embarked from Europe in the steerage compartment of a passenger ship sailing from Germany. Upon his arrival at Ellis Island in New York, he produced the letter from his uncle that guaranteed him a job in South Dakota.

After a physical examination to confirm that he was in good health, Joseph made his way to Grand Central Station in New York City, where he boarded a train to Chicago. Once there, he pinned a small sign to the front of his coat which read, YANKTON. A Good Samaritan helped him find the train to South Dakota.

He was the only traveler to disembark at Yankton. Although there was no passenger station, he saw a cluster of buildings in the distance and began walking toward them. Along the way, he met a young girl and asked her in Czech where his uncle's farm was located. He was amazed to discover that the girl was also from Bohemia, and to learn that many more Czechs had settled there.

Joseph was stunned by the dramatically different landscape of South Dakota from that of his birthplace in Central Europe, and wrote home to tell his parents of the vistas he now encountered. The open, windswept prairie stretched into the distance as far as he could see in every direction.

His uncle turned out to be kind and helpful, urging him to learn English as quickly as possible while adapting to this new land. He was given space to sleep in the attic, and a full share of the many jobs on the farm, including milking cows, bailing hay, planting crops, and repairing fences.

Over the course of his first winter in America, he continued to write to his family in Podebrady about the incredible Dakota blizzards, with their forty below temperatures and howling winds that would drive twenty foot snowdrifts up against the house and barn.

Although he was enjoying farm life, he still dreamed of becoming an artist, and spent his limited spare time sketching and painting everything he saw, including people, farm animals, and the stark landscape. Another creative outlet proved to be furniture design. At his uncle's invitation, he designed and constructed a set of furniture for the dining room, including table, chairs, and sideboard, all decorated in a traditional Czech motif.

Near the end of his stay in South Dakota, he undertook another project that presaged his future career. Presenting his uncle with the sketch of a mural, he proposed to paint one entire wall of his massive barn with a

prairie scene featuring the family's favorite horse. This huge painting drew the admiration of their neighboring farmers, several of whom commissioned Joseph to paint murals on their barns, too. With the money he earned, he was able to pay for the passage of his younger brother Fred to join him in the United States.

With his financial obligation finally settled, Joseph decided to launch his career as an artist in Saint Louis, Missouri, which like South Dakota, had a thriving Czech population. Upon his arrival there, he enrolled at the Saint Louis Academy of Arts, where over the next year he worked to create a portfolio of paintings and drawings. After completing his studies there, he attended the National Academy of Design.

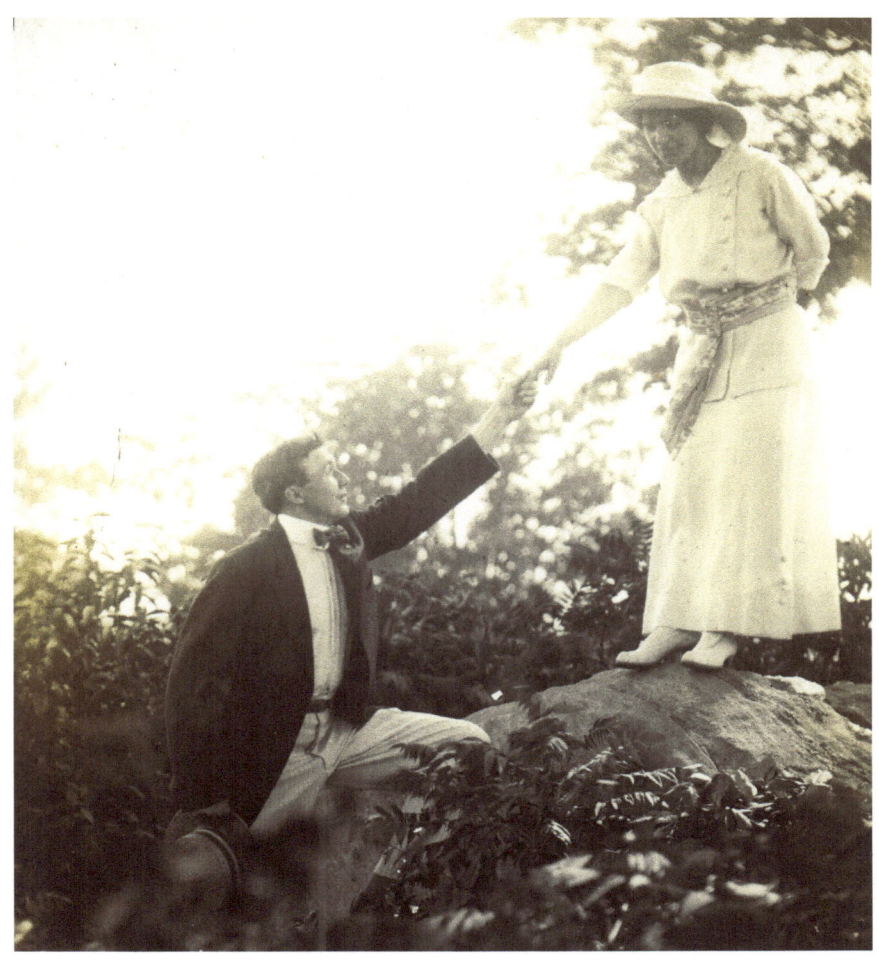

Joseph courting Ada, New York City's Central Park (c1910)

It was in Saint Louis that he met his future wife, Ada Miksickova, a young woman from Bohemia who was there visiting her two brothers, both of whom had emigrated to America fifteen years earlier. Although Ada needed to return home, she promised Joseph that she would seek her parents' approval to come to the United States and rejoin him there.

In 1910, Joseph Mrazek decided to move to New York City, hoping to find success as a commercial artist and decorator. Bearing the portfolio of his work, including the many drawings he had done at the National Academy of Design, he began canvassing the galleries and decorating firms along Fifth Avenue. He began at Washington Square, and proceeded uptown.

At Fifth Avenue and Thirtieth Street, he found the name Hester Decorators in one of the building directories. He assumed it had to be a successful company because they occupied four floors of the building. After arranging an interview, he presented his portfolio and was immediately hired.

His first assignment was to find and train a group of five artists who would accompany him to Boston where Joseph would be responsible for creating the decorative motif for a soon-to be opened Childs restaurant. In the Childs restaurant chain, patrons usually dined in one of several rooms, each decorated with its own theme. The walls were painted with murals depicting famous scenes in American history, mythological characters, or national monuments and parks.

The Boston project proved to be a success, and at the age of twenty-three, Joseph Mrazek was put in charge of decorating all the new Childs restaurants to be opened along the Eastern seaboard. At the same time, William Childs, one of the owners of the company, retained him to decorate several of the rooms in his Manhattan mansion with Mrazek murals.

In 1912, Ada Miksickova was able to emigrate to the United States. She and Joseph were married in New York City. Their first son, Milos, was born two years later. In 1916, Joseph Mrazek achieved his ultimate dream of becoming a naturalized American citizen.

"The United States leads the world in art, in industry, in culture, in progress," he would write years later. "There is nothing impossible for the United States."

The First World War

Although a proud new American, Joseph also retained a great love for the land of his birth. When the First World War began, he joined the freedom movement begun by Tomas Masaryk, a former professor of philosophy at the University of Prague. Masaryk's goal was to create a new nation for the Czech and Slovak people. Its laws were to be based on the United States Constitution.

Being a member of this movement engendered substantial risk. Emissaries from the Austro-Hungarian Empire issued a public warning that if recent emigrants from the empire's holdings chose to enter the conflict against Germany, their families would face reprisals. This policy was carried out to harsh effect.

In 1915, the German Ambassador to the United States, Johann von Bernstorff, began financing sabotage missions to obstruct arms shipments from the U.S. to those nations fighting Germany. Franz von Papen, the German military attaché who would later become Chancellor of Germany, helped to orchestrate the plots.

These crimes included the bombing of the American ship *Aztec* while it lay at anchor in Brooklyn Harbor. Twelve men were killed in the attack. Another nine Americans died in the bombing of two DuPont plants. German saboteurs next blew up a Norfolk and Western freight train that was carrying explosives, followed by the Roebling Wire and Cable plant in Trenton, New Jersey. In 1916, Ambassador von Bernstorff planned what became known as the Black Tom incident, in which a huge munitions depot in New York Harbor was blown up, killing or injuring hundreds of people.

The German saboteurs would have enjoyed many more successes if it had not been for a small band of Czech-American patriots led by Captain Emanuel Voska, an American army officer and close friend of Tomas Masaryk. One of his well-placed agents was Joseph Mrazek.

Posing as a loyal subject of the Austro-Hungarian Empire, Joseph secured a job in the mail room of its embassy, where he covertly steamed open incoming and outgoing cables, photographing the material that was potentially important before forwarding it. It was dangerous work for him and the other agents who had penetrated the embassy.

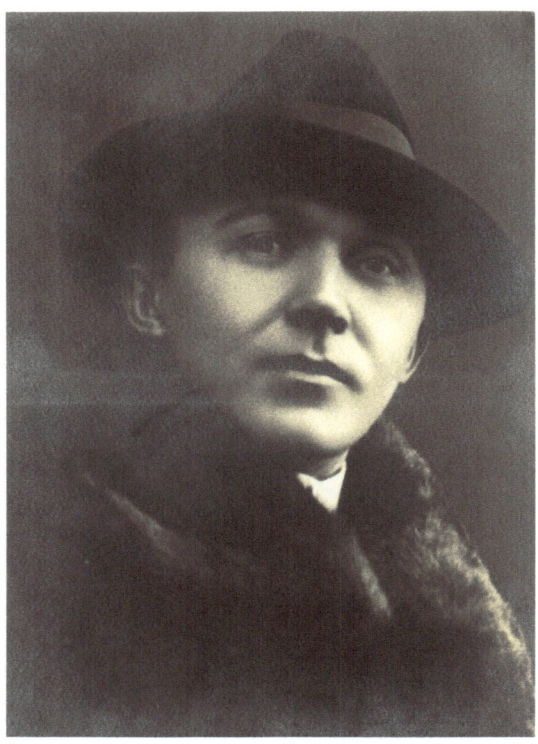

Joseph Mrazek (c1918)

One of his closest fellow agents was Mila Jarushkova, code named "Miss Jay." Poised and beautiful, she had been hired as a governess to the children of the German Ambassador, Von Bernstorff. When the ambassador was recalled to Germany in 1917, she volunteered to go too, continuing to provide important intelligence from Germany.

Caught spying, she was found guilty of espionage, and sentenced to be hung. The war ended before the sentence was carried out. When she finally returned to the United States, Miss Jarushkova went to work for Joseph Mrazek, and remained in his employ until her death.

An Artist's Calling

Again focused on his artistic career, Joseph Mrazek happened to see an advertisement in the New York Times that changed his life. Macy's, already one of the largest department stores in the world, was advertising a ceramics "hobby kit," which included unpainted tableware, camel hair brushes, thinner, and paints. The kit included the free use of a Macy's kiln.

After purchasing the kit and experimenting with its colors, he began painting some of the decorative designs he had created while attending the National Academy of Design. Some of these early designs replicated the bold colors of the holiday costumes worn by peasant women in Bohemia and Moravia that had been immortalized in paintings done by the noted Moravian artist, Joza Uprka.

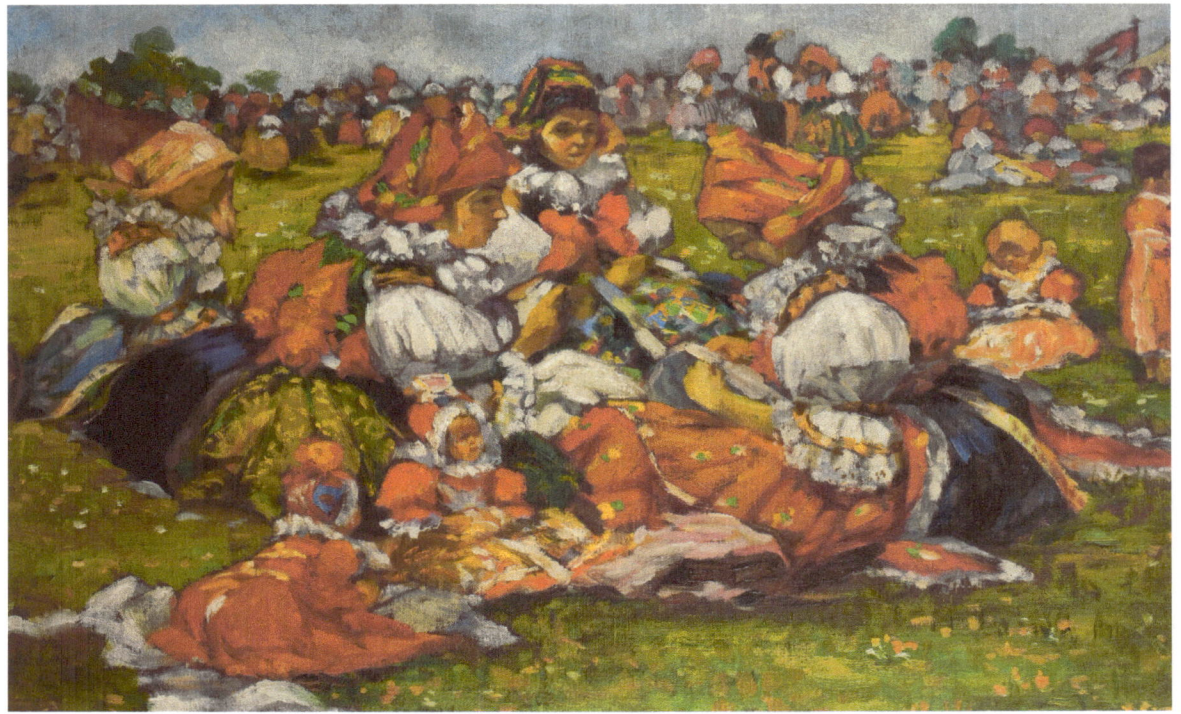

Oil painting by Joza Uprka of peasant girls in field (c1901)

In some of these early designs, Mrazek was particularly drawn to motifs painted in red and orange. When he brought the pieces back to Macy's to be fired in their kiln, the reactions from the decorators employed at the store were very positive.

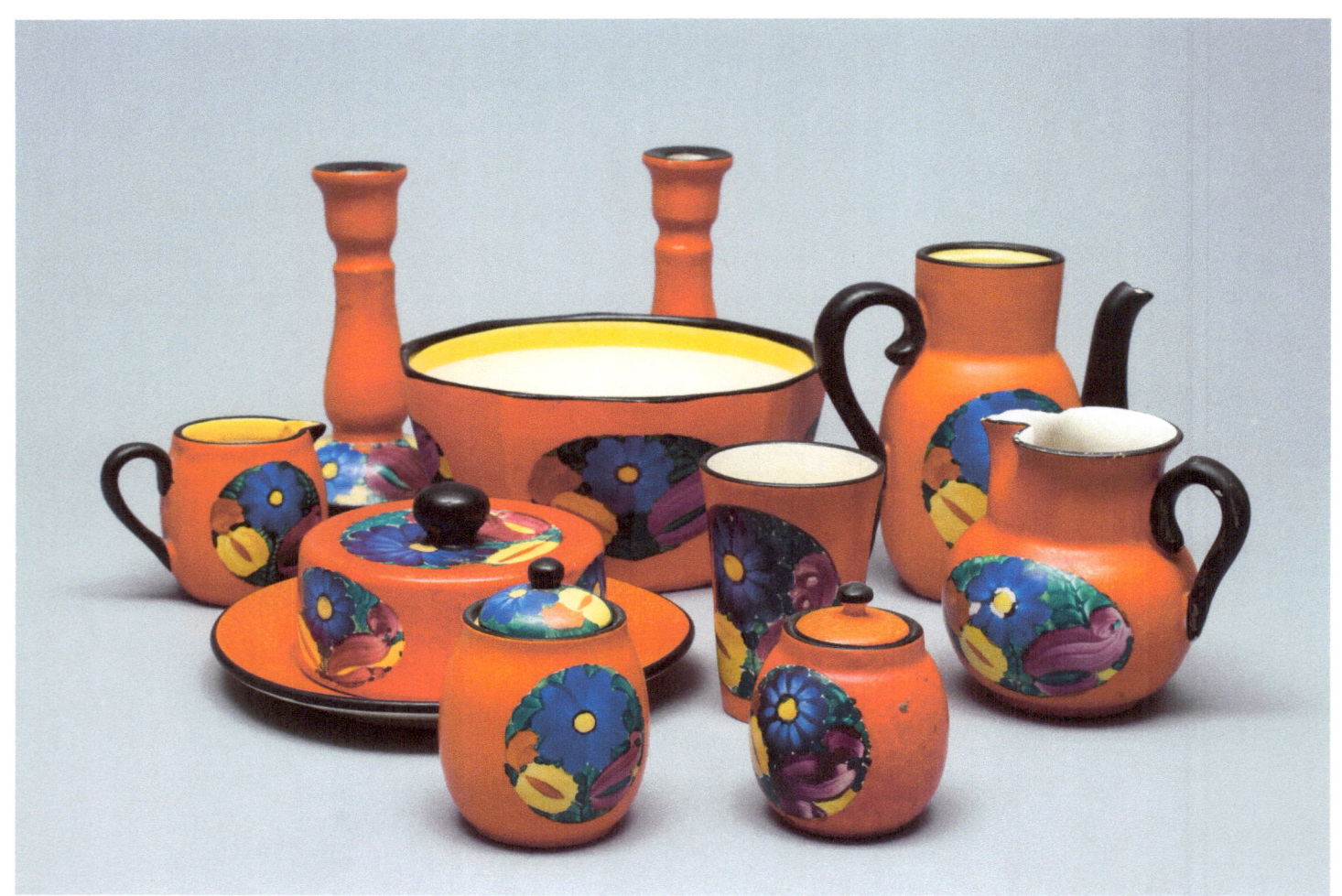

An early traditional pattern of Mrazek pottery

Based on their enthusiasm, he purchased his own kiln, and his future company, the *Czecho Peasant Art Company,* was founded in the kitchen of his and his wife Ada's apartment on East Eightieth Street.

Mrazek needed large supplies of inexpensive white pottery, and he scoured the vendors' bins along Delancey Street to find the hundreds of pieces he needed to produce a sample line.

His entrepreneurial dream soon ran into trouble at home. With every room in the apartment crammed with pottery, Ada told Joseph that she would no longer share her kitchen with the kiln. Their next apartment had two chimneys, one in the kitchen and a second in the living room, which housed the kiln.

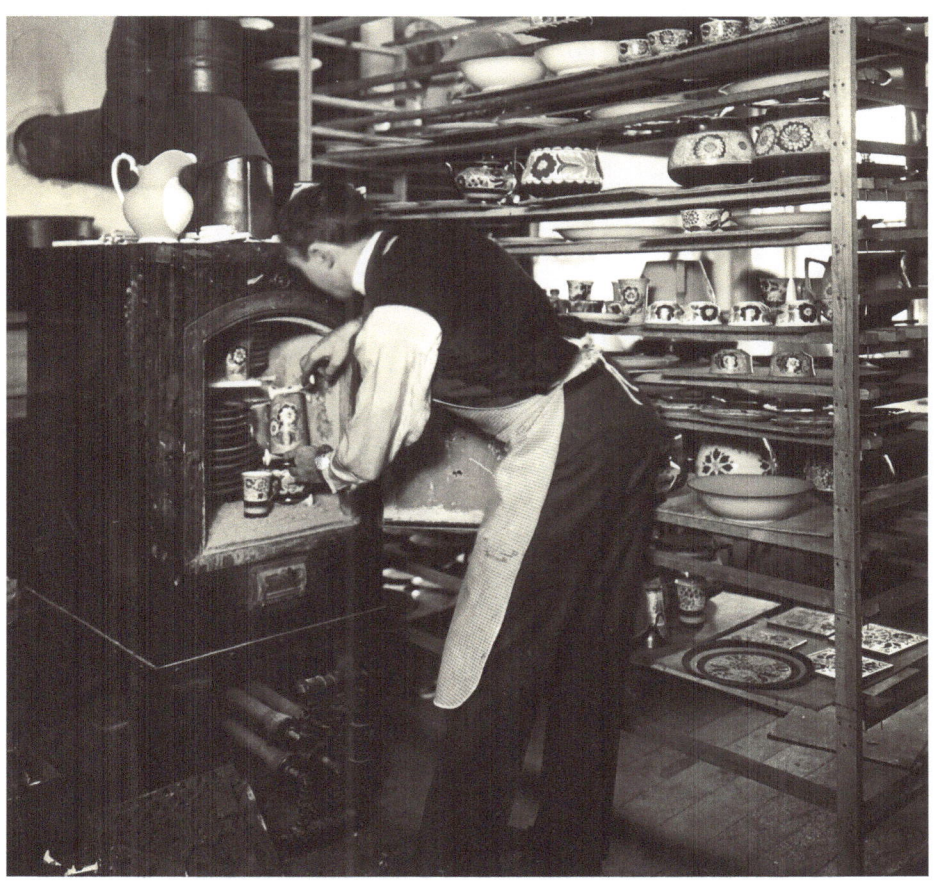

Joseph Mrazek loads his living room kiln (c1917)

Joseph continued creating new patterns until he had produced a complete set of samples. When he showed them to the sales representatives of several department stores, they immediately placed orders.

The war in Europe was still raging, and Joseph divided his time between the war effort and developing his new pottery line. In 1918, his early pieces began to draw notice. Writing in the August 1918 edition of *The Periscope*, art critic Wallace Deland summed up Mrazek's accomplishments at the age of twenty eight.

> *"At present, Mrazek is almost entirely occupied with war work, creating several posters for the purpose of stimulating the recruitment among the Czechs and Slavs, and in his spare time endeavors to propagate the revival of the Czech peasant art, preserving its basic principles while adding a touch of new world intelligence. Mr. Mrazek's many excellent specimens of work are an inspiration. His richness of color, charm of expression, and general symmetry of outline has resulted in a great demand for his work.*
>
> *"The beautiful and decorative vase presented to M. Jusserand, the French Ambassador to the United States, was the product of his labors, and the dinner service of 120 pieces, given to Dr. Milan Stephanik, the famous astronomer and Commandant of the French Aviation Corps, was also decorated by Mr. Mrazek. A flag, designed by Mrazek for the new Czech-Slav State, is already in use at the front by Bohemian battalions.*
>
> *"The Protestant Bohemian Church, (now the Jan Hus Presbyterian Church on East 74th Street, NYC), headed by Dr. Vincent Pisek, is filled with samples of Mr. Mrazek's work, and gives the appearance of being more museum than rectory...To Mr. Mrazek must be given the credit for making this church a veritable landmark, for he decorated all the furniture therein, painted and fired in his own kiln the seven hundred pieces of peasant ware that make up Dr. Pisek's collection, and executed all the mural decorations.*

Dr. Vincent Pisek's dining room, Protestant Bohemian Church, furniture, murals, and decorations by Joeph Mrazek

With orders for his pottery now pouring in, Mrazek decided to lease a large building at 10 West Nineteenth Street in downtown Manhattan. It had four floors and was to become his American base of operations for almost fifty years.

One of the initial challenges he faced was to find talented painters to reproduce the designs to his demanding standards. Although each piece was individually hand-painted, many customers wanted to buy complete sets of the pottery, including six or more place sittings, matching cups, dinnerware, and serving pieces. Each piece had to conform to the same intricate design.

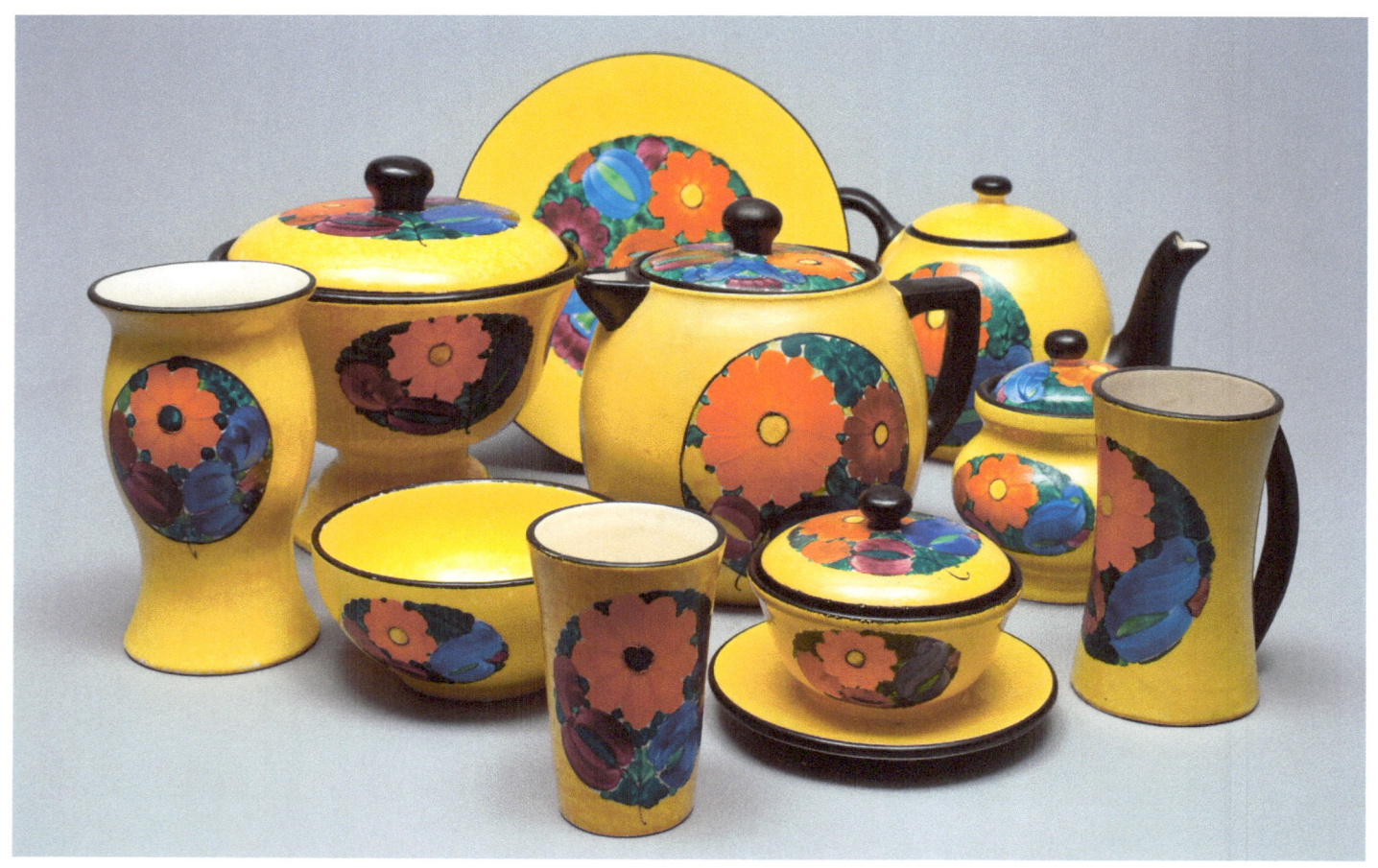

The traditional pattern of Mrazek pottery in yellow

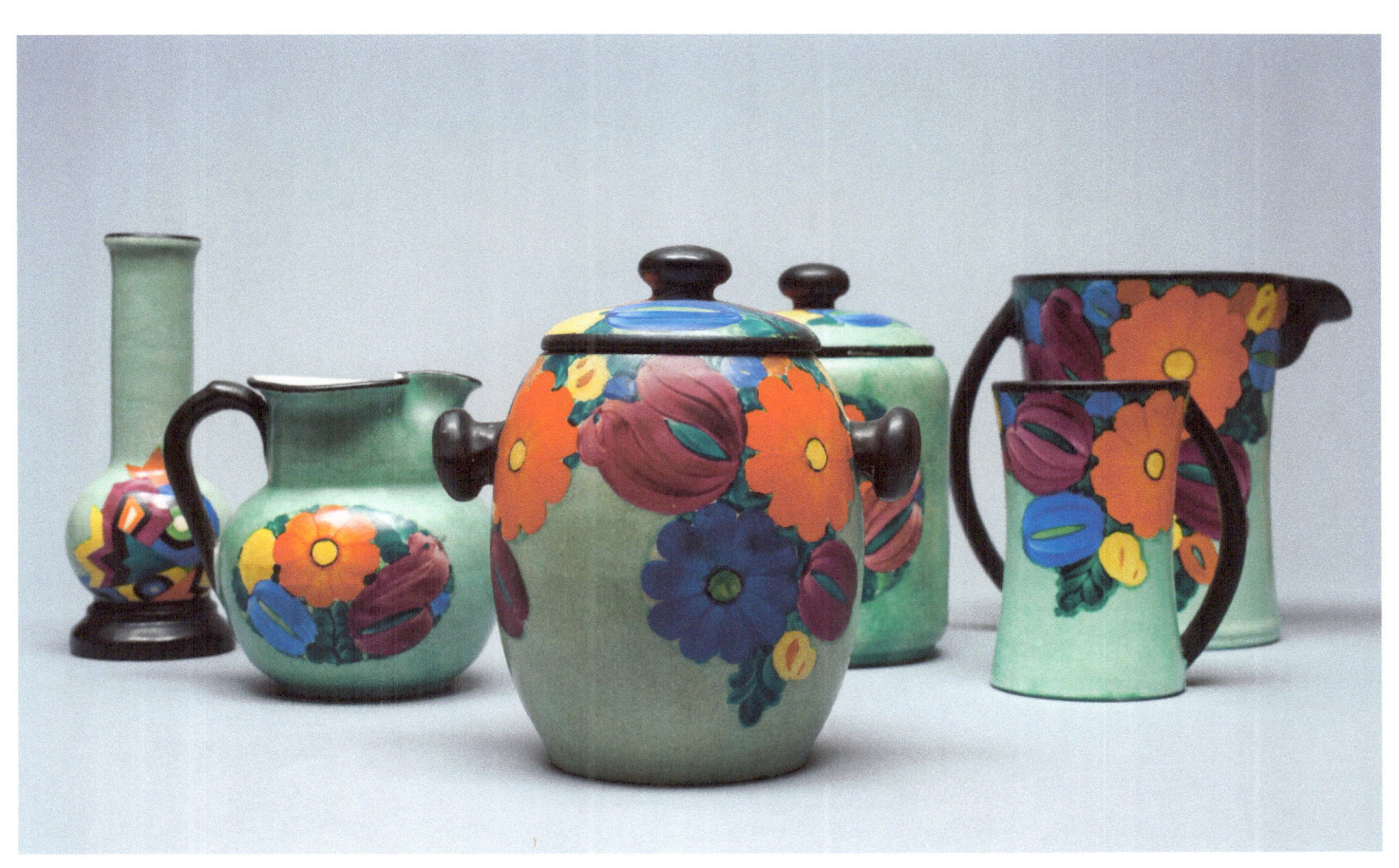

The traditional pattern of Mrazek pottery in green

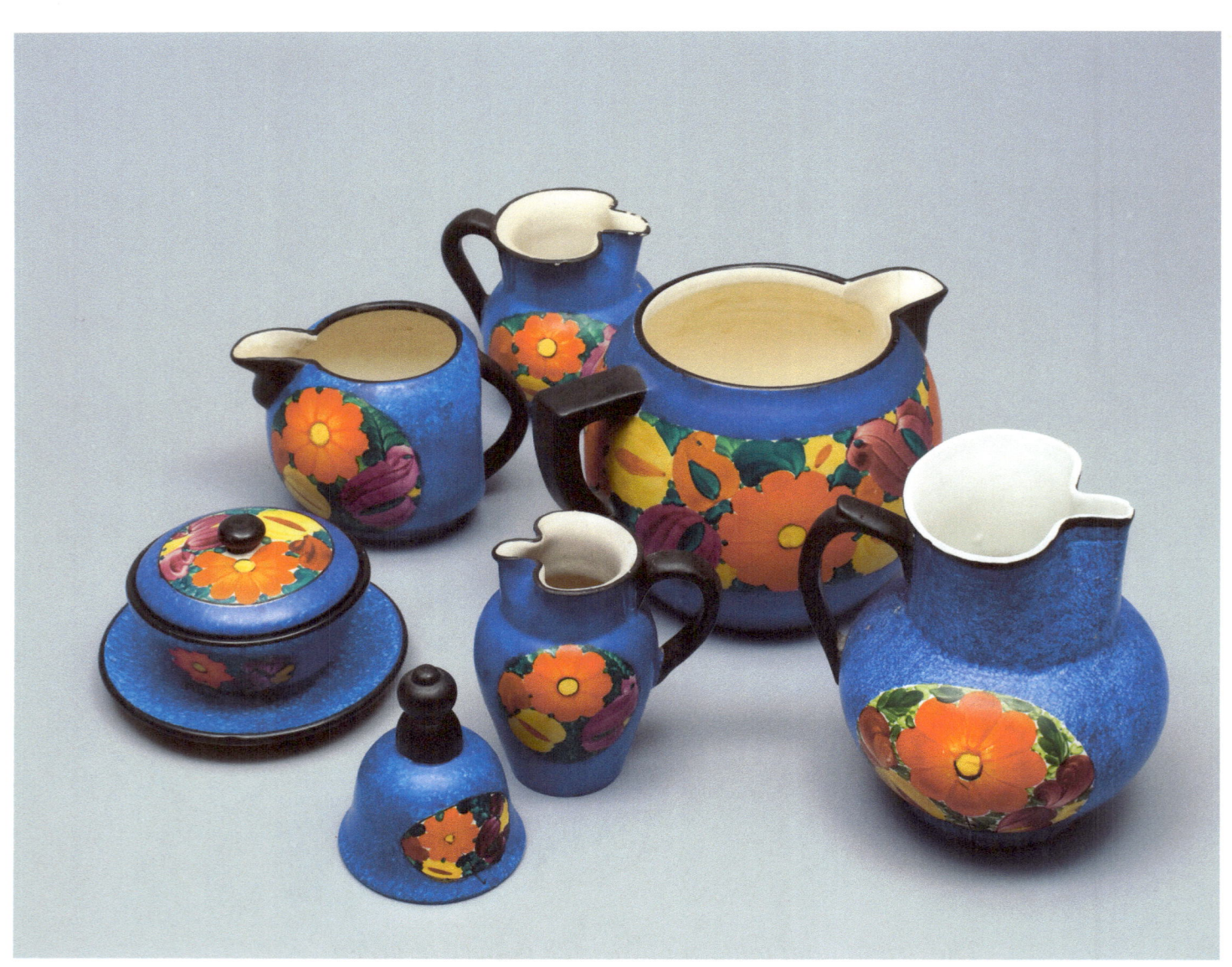

The traditional pattern of Mrazek pottery in blue

The first two painters he retained were his younger brother Fred, who had also become a trained artist, and his sister Antonia, who had emigrated to the United States in their wake. A half dozen more painters were hired in the first months of operation. One of the later arrivals was Mila Jarushkova, "Miss Jay," who had returned from her imprisonment after the war ended, and was thrilled to become part of the new enterprise.

Many of the early Mrazek cups, plates, pitchers, and other dinnerware were distinguished by the mark of a black bird on the underside of the piece. Often the bird was used to hide the original mark of the manufacturer of the unpainted white pottery.

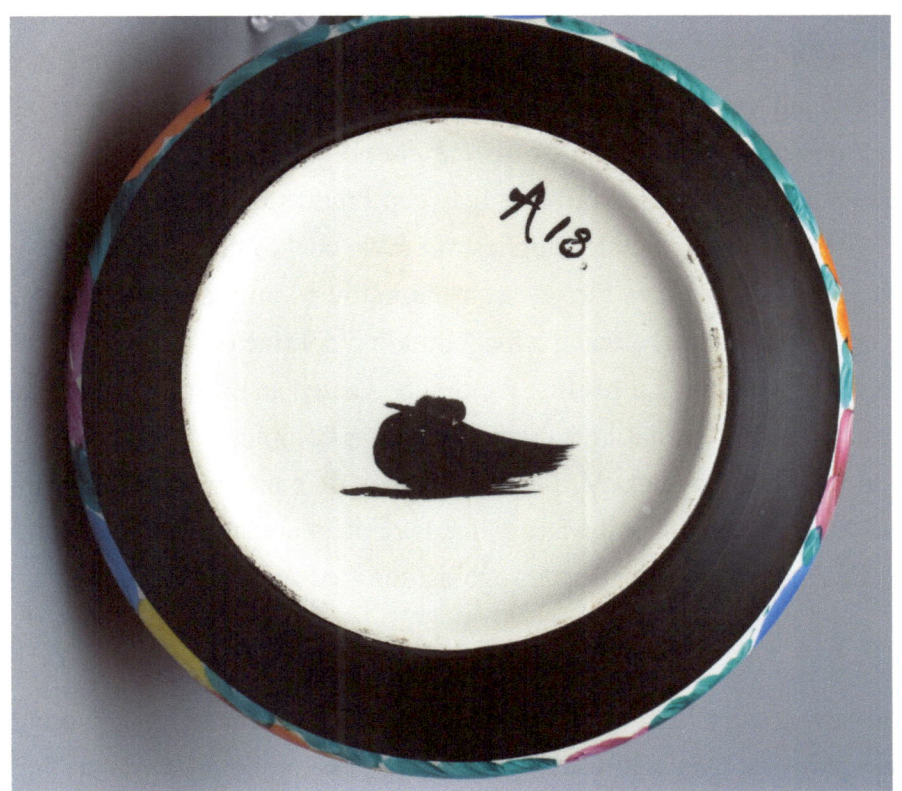

Painted black bird on early Mrazek pottery (c 1919)

The Czecho Peasant Art Company

With the war over, the newly-created nation of Czechoslovakia was in dire need of emergency supplies. Along with a group of other Czech and Slovak artists, including Korbel, Vondrous, Kupka, and Friml, Mrazek helped to organize a nation-wide drive to gather the necessary food supplies and equipment. They then raised the funds to charter a freighter to carry the shipment to Europe, where it was sent by train to Prague. Afterward, Joseph met with President Masaryk and received two medals for his wartime service.

Mrazek was now ready to embark on the next chapter of his entrepreneurial dream. He had already decided to locate his first pottery factory in Czechoslovakia. The question was where. One of the places he subsequently visited was the small town of Letovice in Moravia. Not only did it have substantial deposits of clay nearby, but it was of a very desirable quality that would require no bleaching or coloring. Another advantage was that Letovice was located on the principal rail line between Prague and Vienna, which would facilitate the shipment of his products. There were also ample supplies of brown coal to fire his kilns.

A ten acre site was chosen for the new factory near the Letovice railroad station. Work on preparing the site for the new buildings began immediately, using a local building contractor.

While Mrazek developed the plans for his first factory, he visited an existing pottery factory in the nearby town of Kunstat, and contracted to lease it until his own facility was completed.

Prior to returning to the United States, Mrazek chose his wife's brother Captain Kamil Miksicek to run the Czechoslovakian end of his business. Kamil was a trained architect and army officer who had just returned to Prague after surviving the Czech Legion's epic battles against the Red Army as it fought its way across the vast expanse of Russia. Kamil would draft the architectural plans for the new factory.

Mrazek also needed someone with an artistic background who could maintain his demanding quality standards in decorating the new pottery line. The man he hired was Antonin Danek, a young artist in Letovice. Mrazek spent several weeks showing Danek how the pieces were to be painted, as well as the process for double firing them in the kilns of the newly-leased Kunstat factory.

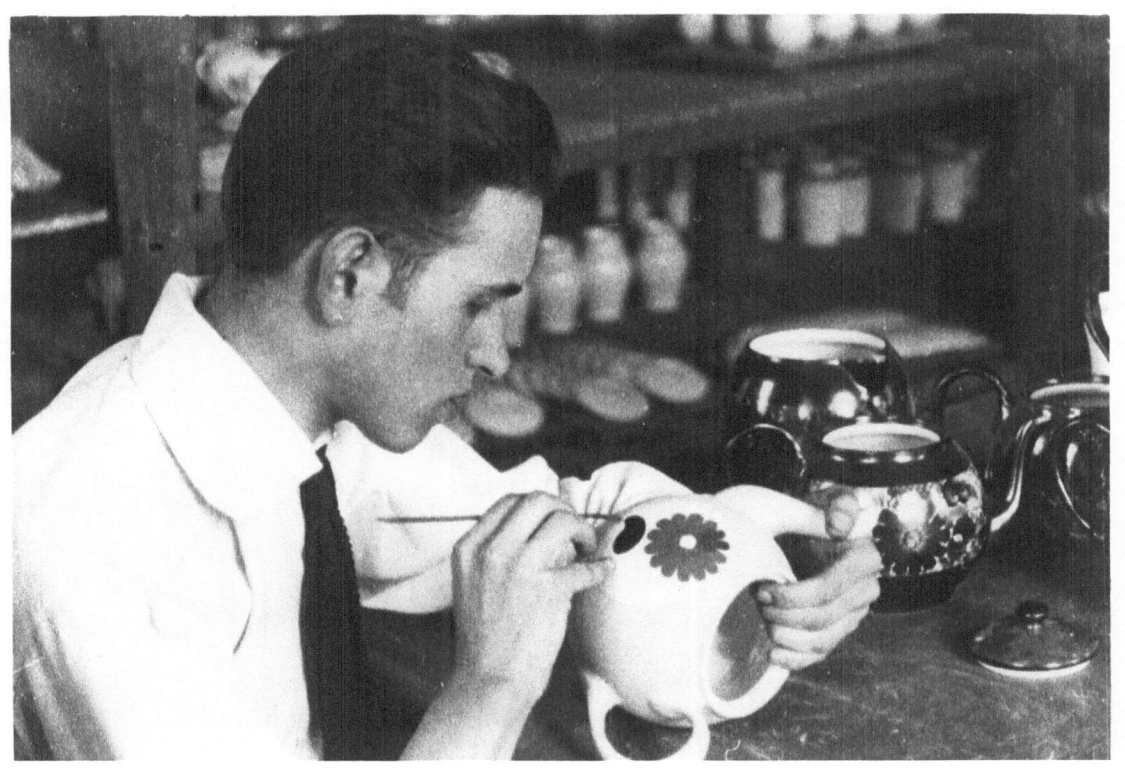

Antonin Danek decorates a once-fired piece of pottery (c1922)

 Now confident that Danek could emulate the style and techniques required, Mrazek placed local newspaper advertisements seeking painters, potters, and decorators. Most of the applicants turned out to be young women of high school age. They were given a series of tests, including the handling of brushes and color with the translucent paints.

 Mrazek's pottery designs required free flowing brush strokes rather than the exact applications of a trained artist. Each petal in the flowers that adorned the pottery was to be painted in just one stroke. Unlike most other hand-painted pottery, he also wanted to give each flower an actual texture that could be felt as well as seen after the second firing process.

 Those applicants who showed promise were immediately hired. After the first group of decorators

was trained by Danek in mixing the colors, application, and layout, the small Kunstat factory was ready for production.

Returning to the United States, Mrazek met his new son Harold, who had been born in New York during his absence. There was little time to enjoy his arrival. The Kunstat factory would soon be in production, and he needed to secure financing for his new business, as well as the capital to construct the factory in Letovice.

Based on the orders already placed by the department stores, long-term financing was quickly secured. Mrazek then made arrangements through the U.S. Customs Bureau to receive the incoming products, and hired sales representatives in several large cities around the country, including Boston, Chicago, Philadelphia, and Miami, to solicit new orders for his designs. A shipping and distribution plan was created to efficiently respond to orders that were already arriving.

With the U.S. component of his company in place, Mrazek returned to Czechoslovakia with Ada and their two sons to begin construction of his new plant in Letovice.

At Kunstat, he discovered that Antonin Danek had done an extraordinary job in reproducing his designs. Thirty employees were already engaged in making the pottery, and all the initial lines met Mrazek's demanding specifications.

By then, Kamil Miksicek had completed his architectural plans, which conformed to Mrazek's desire to place the entire pottery-making process under one roof in order to insure the smooth flow of products from one department to the next, while minimizing the movement of the fragile pieces until they were fired in the kilns. Huge windows provided natural light in every work room.

That first year of operation saw three shipments of Mrazek pottery leave Kunstat for the United States, each consisting of twenty tons of finished work. All the pieces were sold as soon as they could be distributed around the country.

The new factory in Letovice was ready for operation in 1922. Among its unique features were the exterior walls, all of which were decorated with an intricate network of Mrazek's peasant designs.

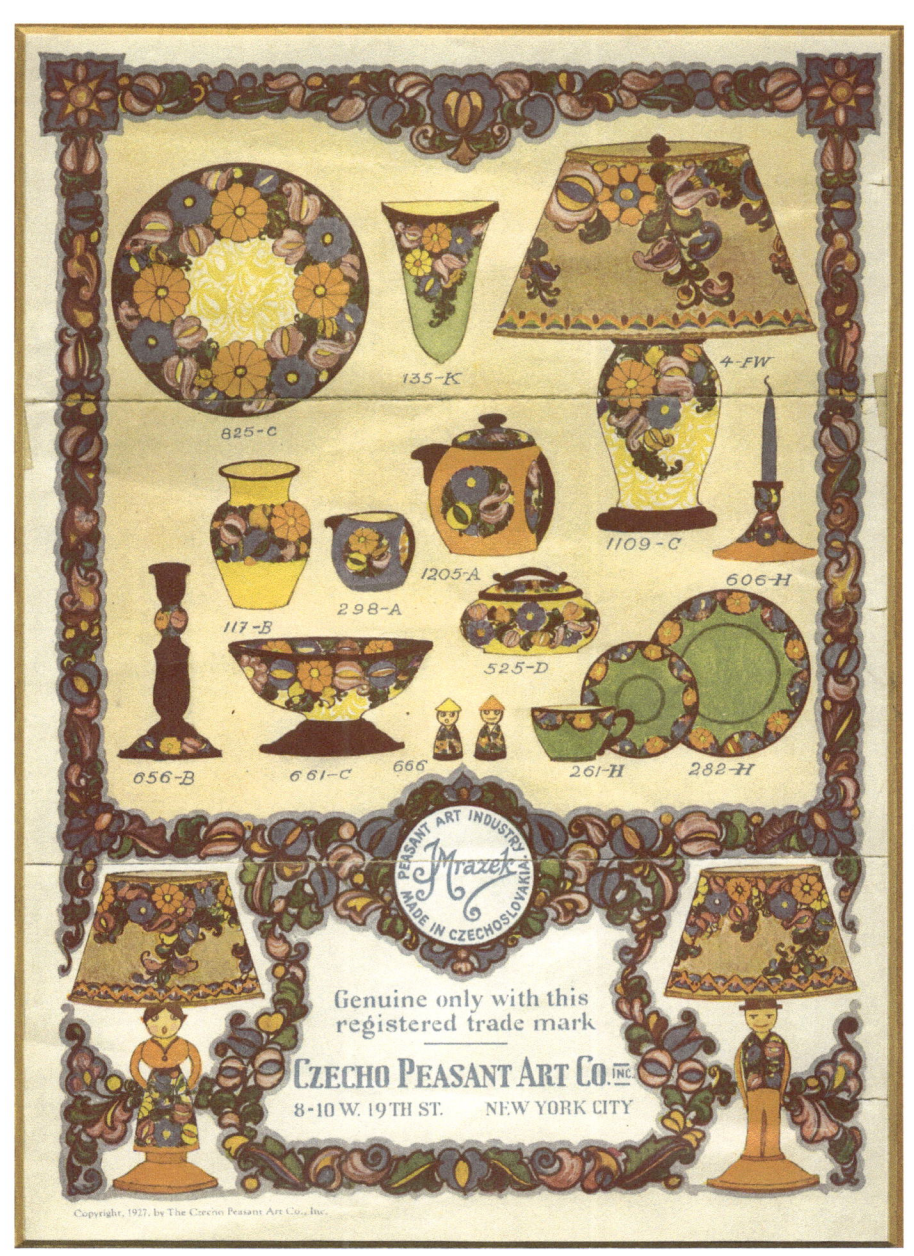

The registered trademark of Czecho Peasant Art Company (c1924)

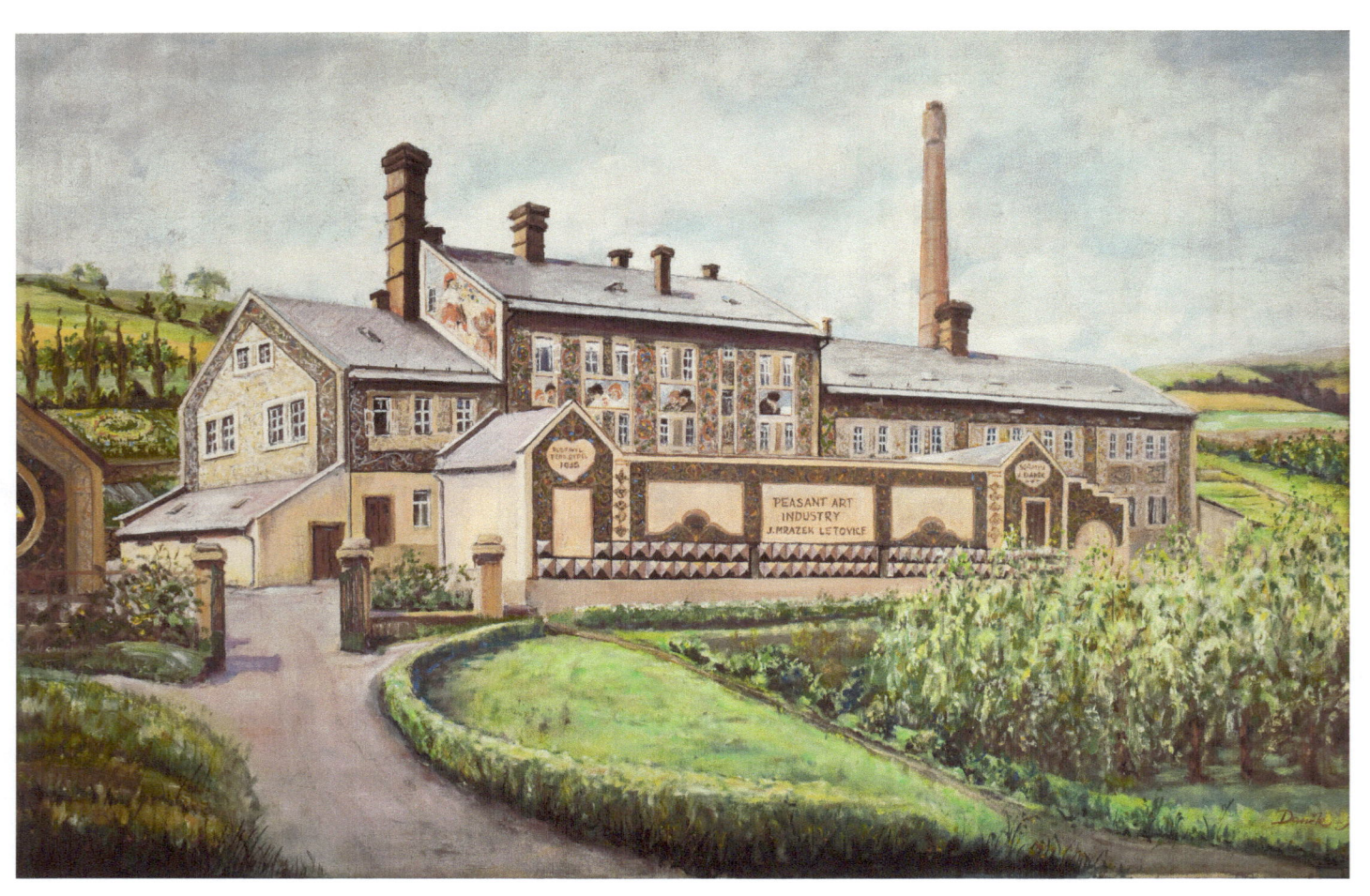

Oil painting of Mrazek factory (c1924) by Antonin Danek

In its second year of operation, a fully-loaded railroad car of Mrazek pottery was being shipped across the Atlantic to the United States every month. By 1923, the factory employed one hundred eighty men and women.

Under Mrazek's stewardship, the Czecho Peasant Art Company became a family-oriented business in every sense. He was one of the first factory owners in Czechoslovakia to provide pension and health benefits to his employees, who were also paid higher salaries than other typical factory workers.

To insure pleasant working conditions, a sophisticated sound system was installed through which operatic and classical music was piped into all the work rooms. Soon, the Czecho Peasant Art Company had its own orchestra, followed by a theater group. Both staged free concerts and plays for people in the surrounding countryside.

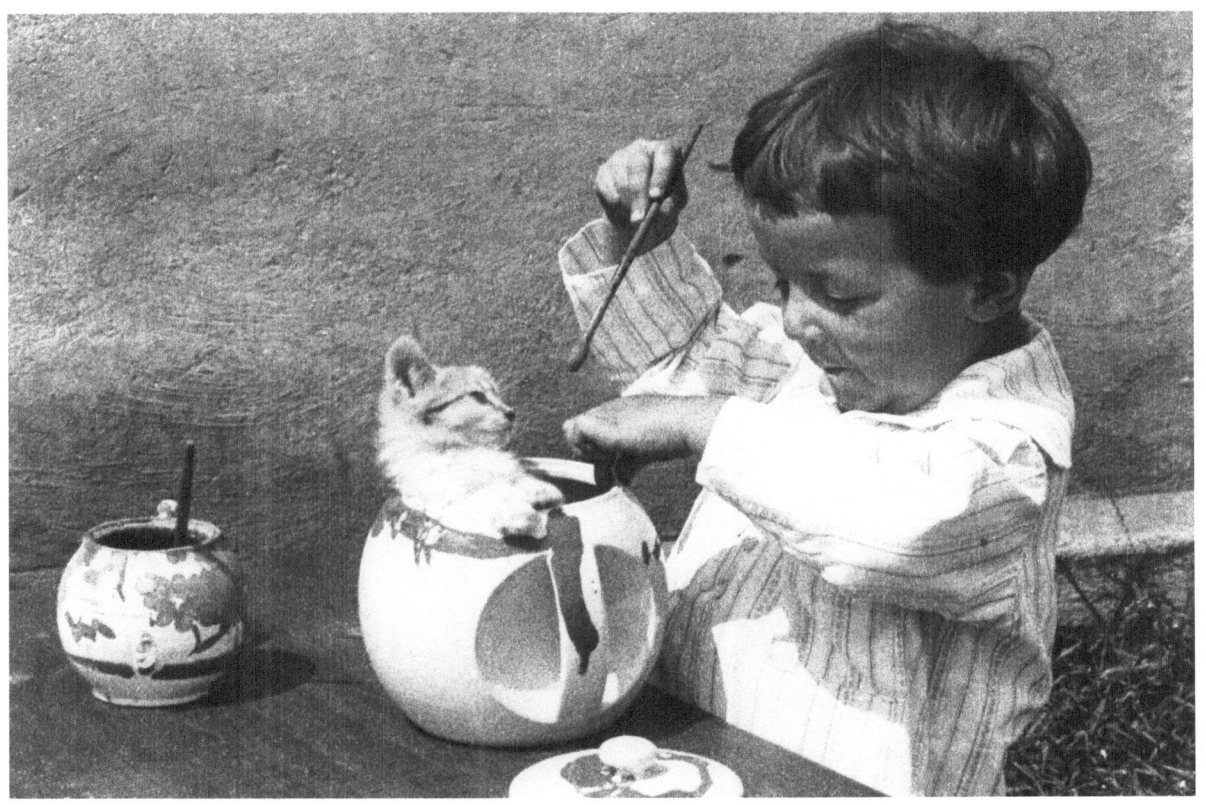

__Harold Mrazek demonstrates his own painting skills (c1926)__

Although Joseph Mrazek's early pottery designs were continuing to sell as quickly as they could be produced, he introduced a fresh line of new pottery every year. Through the late 1920's, Mrazek's traditional motifs always remained available for order, but his new designs reflected the dramatic changes taking place in the European art world.

One of his most collectible pottery lines emerged from his own continued growth as an expressive artist. Now referred to as his "art deco" period, the abstract cubist patterns of this line were influenced by the work of his friend, Frantisek Kupka, a brilliant Czech painter.

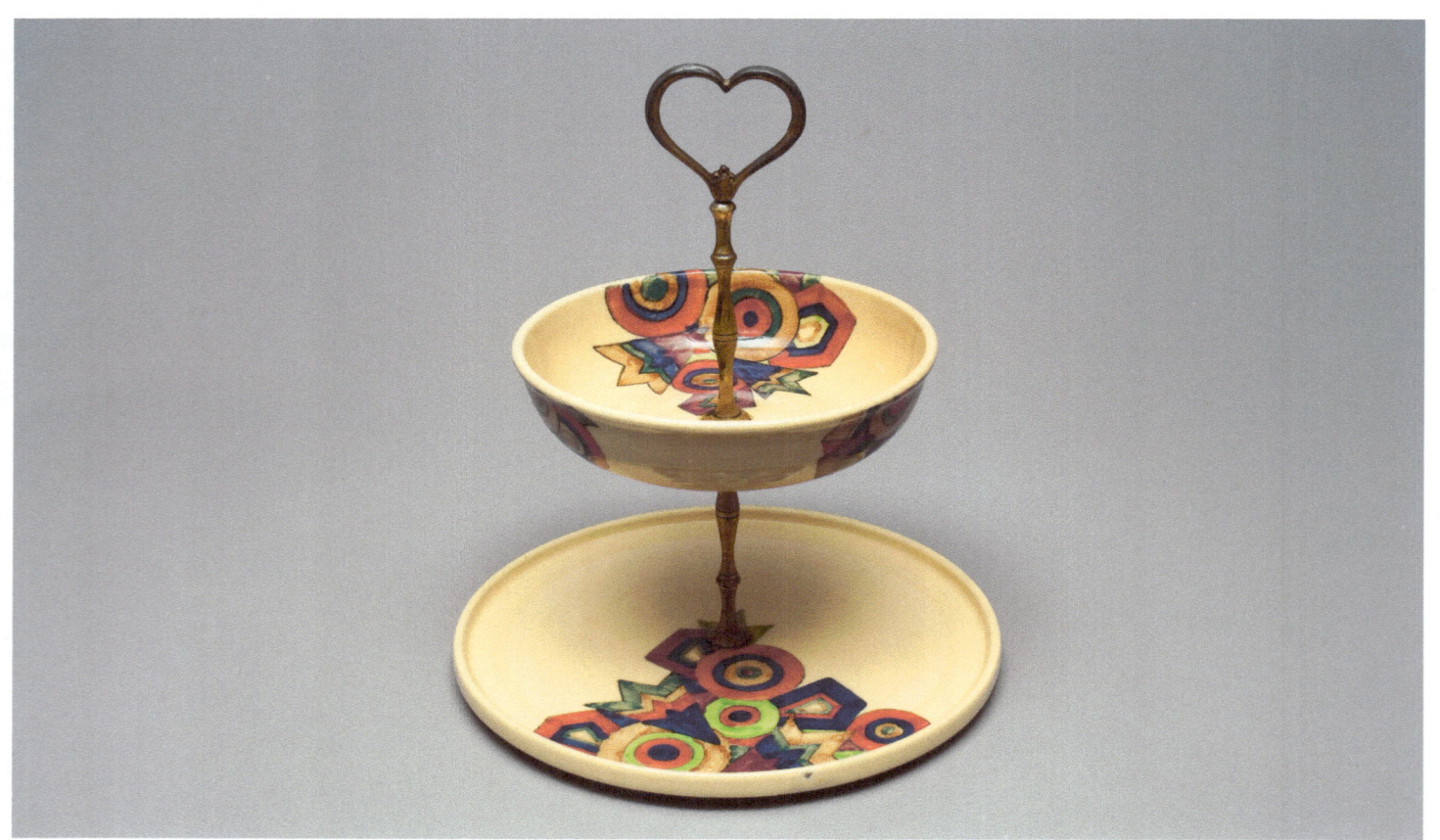

Two-tiered serving piece, Cubist, (c1928)
H 13" W 10"

As the years passed, Joseph Mrazek's pottery achieved a succession of awards and prizes, culminating in his winning the gold medal for pottery at the World's Fair Exposition in Philadelphia, Pennsylvania in 1926.

The fair was attended by more than ten million people, and top exhibitors were invited to showcase their work in a celebration of the 150th anniversary of the signing of the U.S. Declaration of Independence. Hundreds of ceramics makers from all over the world competed for the pottery prize.

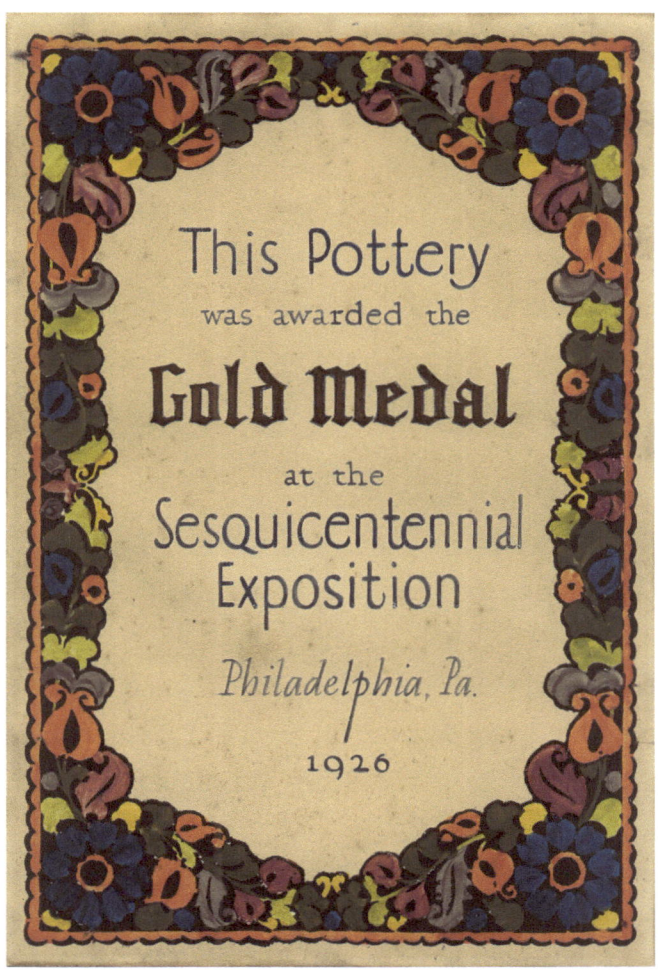

Gold Medal Citation for Mrazek Pottery (1926)

With the unalloyed success of his pottery line, Joseph Mrazek encountered his first wave of imitators. In spite of patent protection, Japanese, German, and French companies began copying his designs. They soon began flooding the pottery market in the United States with cheap imitations.

Writing in the 1929 *Pottery Salesman*, Blanche Naylor chronicled Mrazek's pre-eminence in creating his own unique pottery style, *"which combines grace of form with traditional designs...The most significant tribute which can be paid to any successful work of art is its imitation. In Mrazek's case, this has been true, and copies both fair and bad have been produced in many places. A careful observer finds that the coloring, the placement of the decoration, and the finish in general cannot be compared with the original work."*

Buoyed by the fact that he could no longer keep up with the orders for his pottery lines, Mrazek decided it was time to build a second factory. Even larger than the first one, it was scheduled to come on line in 1930. Unfortunately, his timing wasn't fortuitous.

On October 29, 1929, the New York stock market crashed in what became known as "Black Tuesday," triggering a worldwide economic depression. Even after its first impact was felt, Joseph Mrazek's confidence in the U.S. economy was so great that he believed the setback was only temporary, and forged ahead with construction of his new factory while maintaining full production capacity at the existing one.

With the close-knit bond he felt to his employees, he was reluctant to fire anyone, regardless of the economic downturn. For a year into the depression, he continued shipping his pottery to the United States. It was only when his customers began declaring bankruptcy and forfeiting their financial obligations that he begin to curtail production.

As his cash reserves began to melt away, the final blow came with the news that the American government, anxious to protect jobs at home, was revoking the "most favored nation" status for goods manufactured in Czechoslovakia. The new tariffs suddenly made his pottery line far more expensive than domestically produced pieces.

In 1931, Joseph Mrazek returned to Czechoslovakia to personally deliver the news to his hundreds of employees that it was necessary to shut the factories down. He retained a handful of key personnel, including Antonin Danek, to manage the shuttered properties. It was a bitter defeat to accept. When he left for the United States, it was never to return.

Back in New York, he proceeded to mothball his domestic pottery operations, and the company's sales offices were closed across the country. Joseph Mrazek's landlord at 10 West Nineteenth Street allowed him to keep it without paying rent. The arrangement lasted for three years, when Mrazek was again able to begin making payments. Eventually, he repaid the entire amount.

One of the patents secured by Joseph Mrazek to protect his designs (1926)

Ada always retained her optimism in spite of hard times (c1931)

Another Beginning

In 1933, Joseph began accepting consulting assignments that allowed him to utilize both his artistic and decorating talents. On June 12, 1934, the Cincinnati Times Star reported his arrival there in a story headlined, *"Ceramics Expert, Power in Dethroning a King, At Freelands."*

Mrazek had been retained by W.T.H. Howe, the President of the American Book Company, to arrange Howe's substantial collection of early American glass and to redecorate a number of rooms at his estate, called Freelands. Mrazek spent most of the summer on the project.

While continuing to take on consulting assignments, he also began researching the use of plastic to make lampshades that were more transparent than glass. Many of these prototypes were later purchased by Howe and showcased at Freelands.

In 1935, he invented a plastic that was virtually unbreakable and could be decorated just like his pottery. Under the trademark, MAROLIN, he created a new line of decorator items, including vases, bowls, and serving pieces. This line was marketed by the fashionable retailer, Rena Rosenthal, whose shop was located in the Waldorf Astoria hotel, as well as through the Marshall Field department store chain. Mrazek's Marolin process was also used to create life-like manikins and window displays for high end department stores.

Mrazek then secured a patent for printing on plastic in which colorful designs could actually became an integral part of the material. It was a revolutionary breakthrough, and he was beginning to market the patent for future applications when several plastics companies illegally copied his formula from the US Patent Office and began producing it themselves. Without the resources to engage in major litigation over patent infringement with companies that employed staffs of patent lawyers, Mrazek moved on.

His creative enthusiasm soon took him in a new direction, which became his greatest source of professional satisfaction in the years leading up to World War II.

In the mid 1930's, a new generation of Broadway stage designers had risen to prominence, including Harry Horner, a student of the impresario Max Reinhardt, Boris Aronson, who had made his reputation in New York's Yiddish theaters, and Isamu Noguchi, who designed sets for Martha Graham's dance productions.

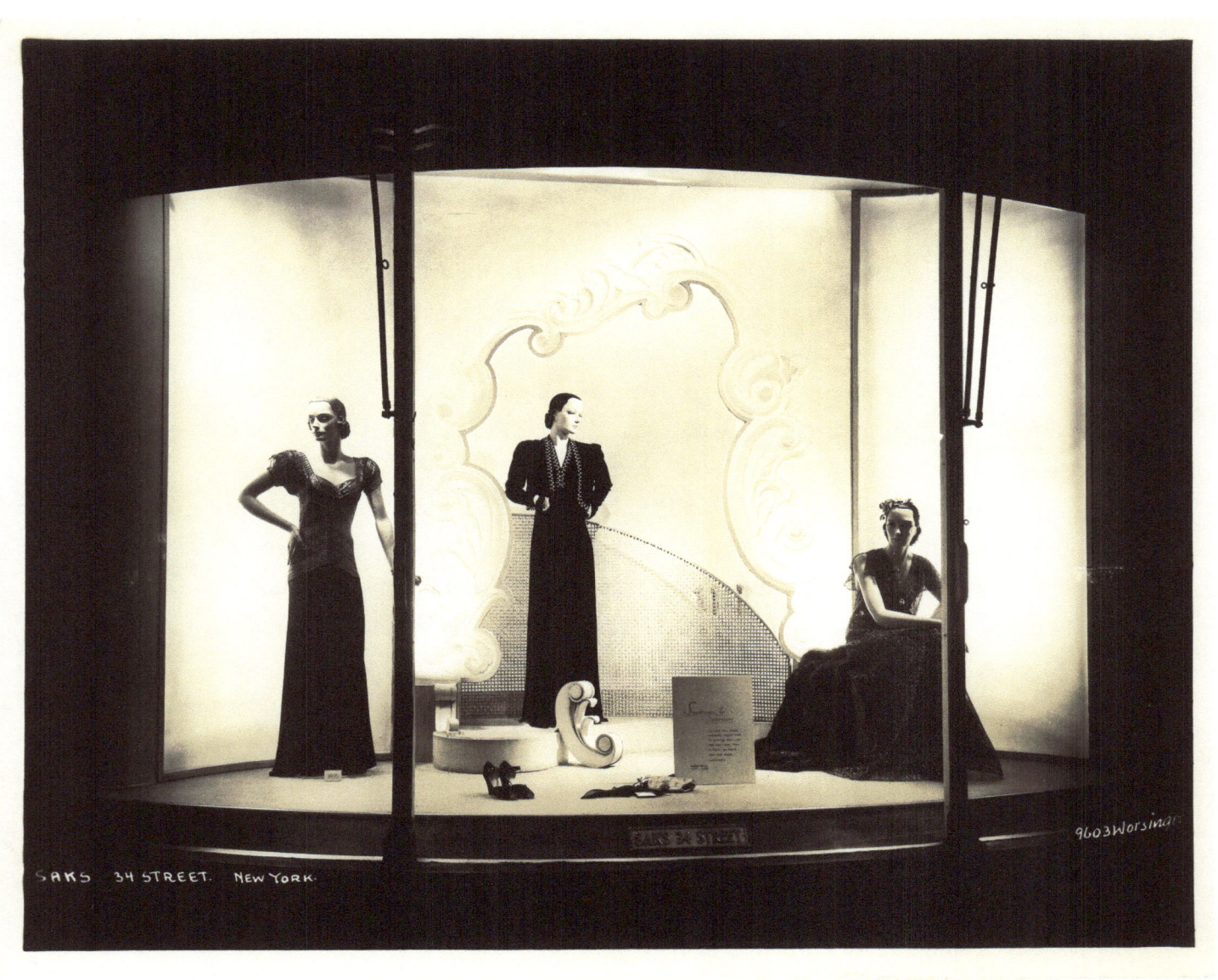

*Window display at Saks 34 store
in Manhattan (1937), Boris Aronson designer*

Like Joseph Mrazek, Harry Horner had been born and raised in Bohemia. The two men had met in New York and become friends. In 1940, Horner was looking for an alternative to the heavy and cumbersome traditional stage sets constructed from wood and canvas. When he learned of Mrazek's pioneering developments in plastics, he sought out his collaboration.

Using his patented MAROLIN process, Mrazek promised Horner a lightweight, flexible alternative that could be painted as easily as wood, be molded into a variety of shapes, and moved with ease between scenes.

He delivered on the pledge with one of the most successful musical productions of the 1940-41 Broadway season, *Lady in the Dark*. It became the first of many collaborations with Horner in the following years.

Lady in the Dark, with music by Kurt Weill, lyrics by Ira Gershwin, and starring Gertrude Lawrence, Victor Mature, and Danny Kaye, told the story of an unhappy fashion editor who is undergoing psychoanalysis, and whose treatment leads to three extended dream sequences, the glamour dream, the wedding dream, and the circus dream. The stage design was a critical component in delivering this fantasy story in a compelling way.

Boris Aronson, another innovative stage designer, was also looking for new approaches to mount his stage designs. This led to Mrazek's contribution to another Broadway hit, *Cabin in the Sky*, which starred Ethel Waters and Dooley Wilson.

Cabin in the Sky told a version of the Faustus legend in which Little Joe, a black man killed over gambling debts, is given six months to redeem his soul and earn a chance at Heaven, or face the alternative. The stage sets were required to vividly illuminate these choices. Again, Aronson's designs and Joseph Mrazek's fabrications created settings that were almost as important as the performances.

In the years that followed, many Broadway stage productions, as well as those at Radio City Music Hall, had either Joseph Mrazek or Czecho Peasant Art Company in their credits.

By then, both of Mrazek's sons had joined him in the family business. Older son Milos had become his trusted lieutenant, responsible for executing his plans and designs for each new product that grew from his imagination. Younger son Harold, still a teenager, was learning the business as a fabricator and decorator.

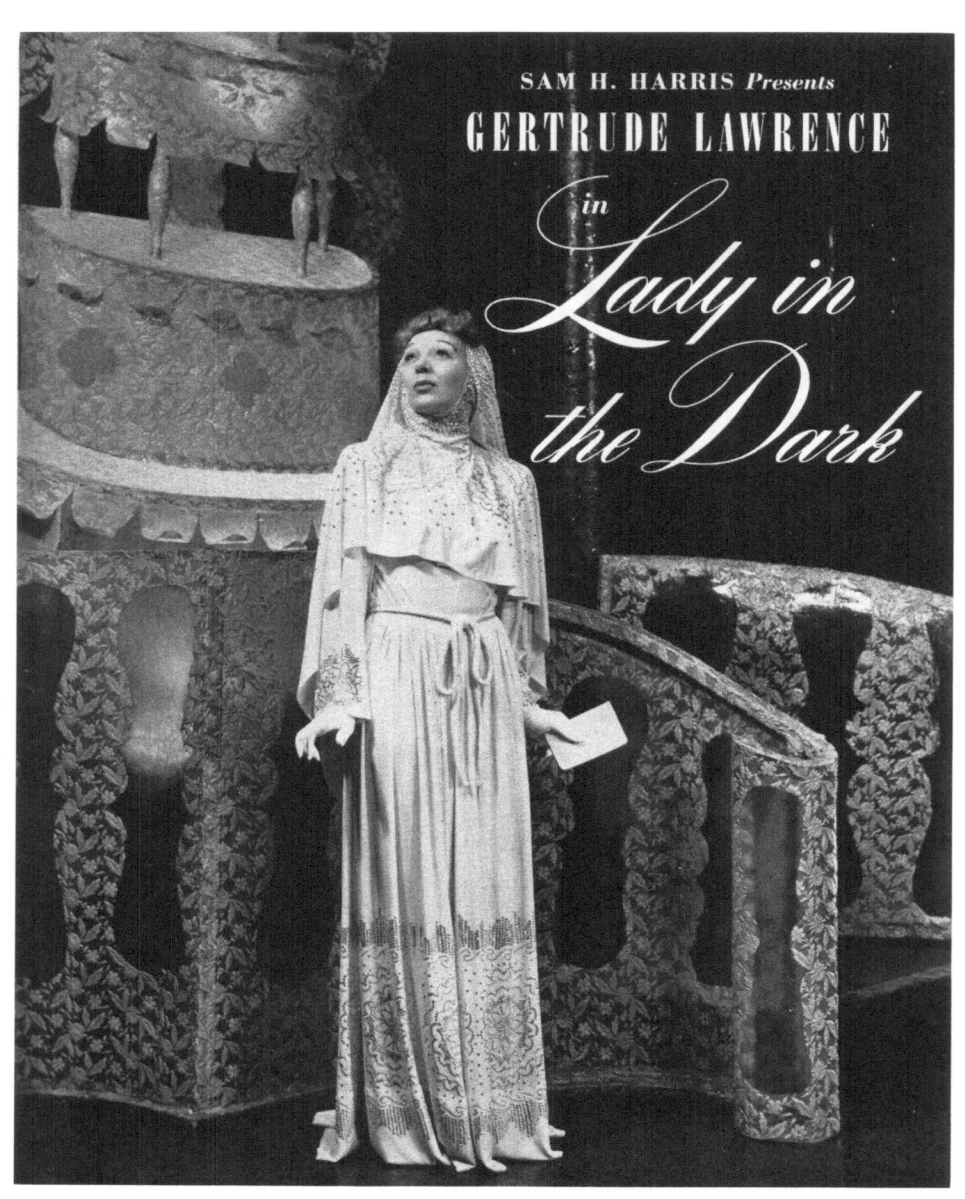

Mrazek stage set from Lady in the Dark. A 14 foot high wedding cake from the fantasy marriage scene, Harry Horner, designer (1941)

The Second World War

World War II quickly changed the family dynamic of the company. In early 1942, Harold Mrazek was recruited by Captain Emanuel Voska, who had been Tomas Masaryk's intelligence chief in the First World War, to join the newly-created Office of Strategic Services (OSS), and he left the company for training as an undercover agent in German-occupied Europe.

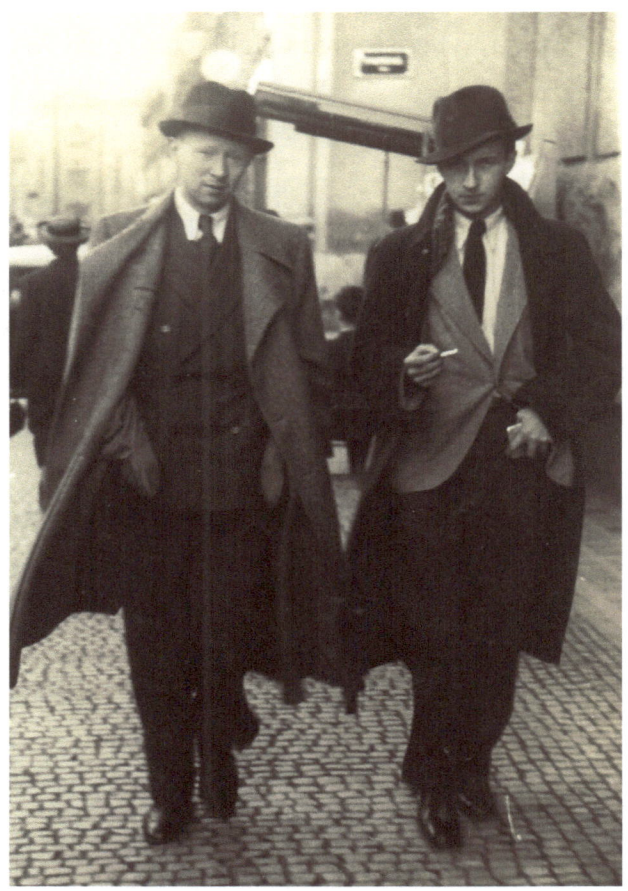

Harold Mrazek, on the right, World War II

Now fifty-three years old, Joseph Mrazek was as ardent to participate in the defeat of Germany as he had been in the First World War twenty-five years earlier. He yearned to make a contribution to winning the war.

It arrived in the form of a request for help from the U.S. War Department. A new radio compass antenna had been invented for U.S. military aircraft that could enable a pilot and navigator to determine exactly where the plane was, day or night, in any kind of weather. The new antenna was a critical tool in navigating across the vast reaches of the Pacific or in the deadly skies over Germany.

The loop antenna was about ten inches in diameter and rotated on its axis. It could be attached on top or underneath the fuselage of the plane, but the antenna needed to be protected from snow, rain, and ice, as well as the buffeting it would receive in an aircraft flying at three hundred miles per hour. The housing could not be metallic because it would interfere with reception of the electrical signals. The War Department concluded that the ideal housing would be made of non-conductive plastic.

Moving forward without competitive bidding, they awarded a contract to the General Electric Corporation to manufacture the housings using a plastic formula patented by the Bakelite Corporation. The protective housings were to cost $300.00 each.

Through a friend, Joseph Mrazek learned that General Electric was having problems fabricating the Bakelite housing to the specifications required by the War Department. All of its prototypes had failed to meet the government requirements for durability and strength.

Mrazek contacted the war Department and inquired whether it was possible for him to submit a bid to fabricate the antenna housing. After receiving approval to do so, he spent several weeks developing his own prototype using the Marolin process. He then sent the housing prototype to the War Department to conduct their rigorous testing protocols.

The plastic housing had to survive temperatures ranging from 70 degrees below zero to 120 degrees Fahrenheit, and was subjected to sandblasting tests equivalent to a desert sandstorm at speeds exceeding 400 miles per hour.

Mrazek's antenna housing passed every test, and the War Department's procurement office wrote to ask him what he would charge the government to produce the housings. After reviewing his costs, he wrote back stating that he would charge $11.00 per housing, which was his break-even figure, adding that he did not wish to profit on the venture, and that he viewed the project as his way of helping to defeat Germany and Japan.

By the end of the war, he had produced more than seventy thousand of the antenna housings. They went into battle with virtually every American military aircraft in the Second World War.

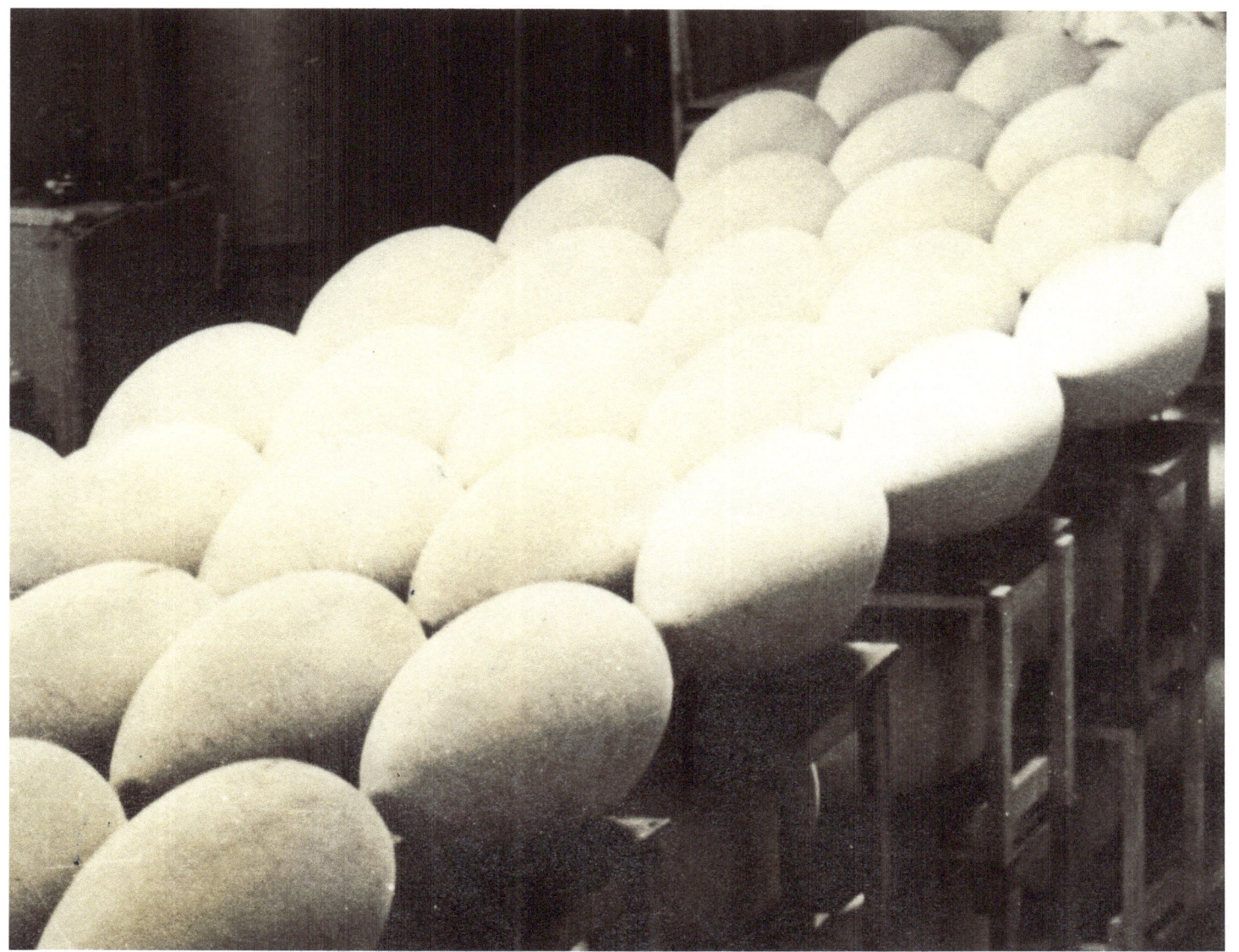

Section of assembly line for Mrazek's antenna housings (1942)

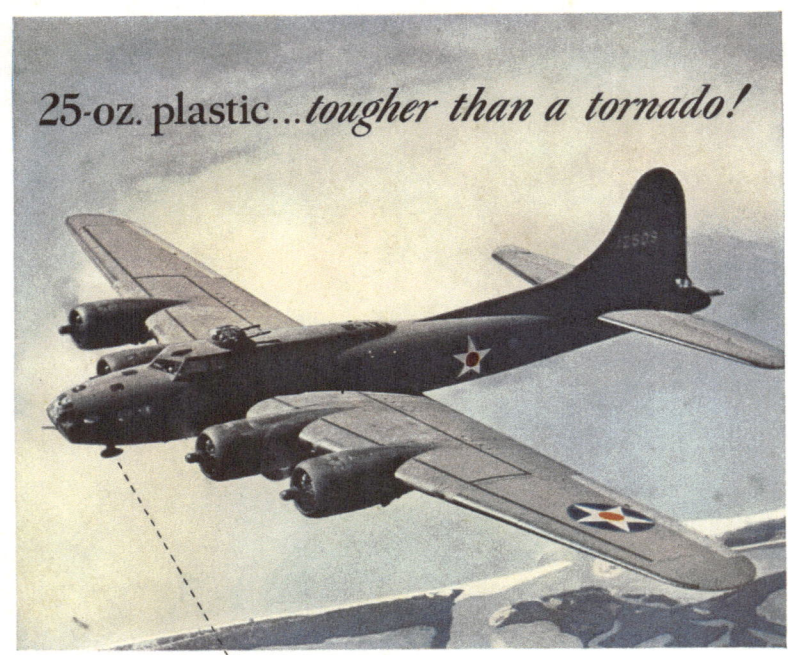

Reprint of advertisement from Time magazine hailing Mrazek's housing as "tougher than a tornado!" (July 11, 1942)

A New Artistic Direction

With the war ended, Joseph Mrazek felt a renewed sense of optimism about his business opportunities. Ever since the depression had wrecked his pottery business, he had hoped to some day reopen the pottery factories in his Czechoslovakian homeland. Although his factories had been converted to other uses by the German occupiers, he received a written report from Antonin Danek, confirming that a modest investment could restore them to their former glory.

In the United States, the exclusive department stores that had carried his line back in the 1920's showed enthusiasm for promoting and marketing another line of Mrazek pottery. He was in the process of seeking financing for the effort when the political situation in Central Europe began to deteriorate. Josef Stalin's Soviet Union had no intention of allowing Czechoslovakia to retain the same freedoms it had enjoyed before the war.

Jan Masaryk, the son of the nation's founder, strongly challenged the Soviet's intention to make Czechoslovakia a vassal state. In the wake of his suspicious death, the Communists took power in Prague. Along with many other privately owned businesses, Joseph Mrazek's factories were nationalized by the Communist government.

It was the end of Czecho Peasant Art Company.

In the years after the war, Joseph Mrazek continued to fabricate stage sets for Broadway, Radio City Music Hall, and the Metropolitan Opera. He also developed new product lines for Marolin plastic.

As his creative energies finally began to ebb in 1954, he gave up his building at 10 West Nineteenth Street, and purchased a home in Centerport, Long Island, where he retired with his wife Ada. In addition to the main house, there was a separate cottage which he converted to a working studio.

One of his passions had always been sculpture, and he now created a range of clay figures that he fired in his kiln, replicating the pieces in Marolin plastic. In one of his visits to Mrazek's studio, Isamu Noguchi, the artist and stage designer, became enamored with the process, and Mrazek began replicating Noguchi's sculptures, along with those of other artists.

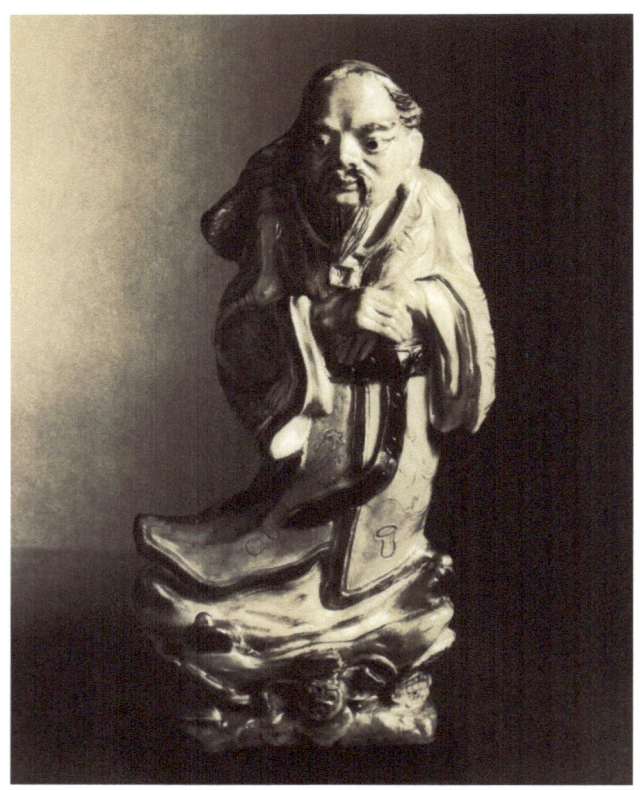

***Hand-painted statue by Isamu Noguchi,
fabricated in Marolin plastic by Joseph Mrazek (c 1947)***

 In the early 1950's, Joseph Mrazek's immediate family would make a weekly pilgrimage to his home for expansive Sunday dinners that featured Czech dishes such as roast pork, dumplings, and cucumber salad, beef roulades and veal paprika, with rich Czech pastries for dessert.

 In addition to his sons Milos and Harold and their families, there would often be house guests from every facet of Joseph Mrazek's past life. Many of them seemed glamorous and exotic to the younger Mrazeks, as they spoke various European languages and often dressed in cosmopolitan fashions and furs. The enclosed porches of his home would be filled with the aroma of good cigar smoke, while he and his guests would discuss art, literature, opera, theater, and music.

It came as a surprise to the younger Mrazeks that everyone else called Joseph Mrazek, "Boss." His old friends called him Boss. His sons called him Boss. His wife called him Boss. Everyone but the small children called him Boss.

Mrazek had earned this soubriquet in the days after opening his first factory in Letovice. Free for the first time from the petty princes who had once ruled Bohemia, he preferred informal greetings to formal titles, and encouraged his employees to address him by his first name. Traditions in Central Europe died hard. Employees uncomfortable with calling him by his first name began calling him Boss as a demonstration of respect. It seemed to fit.

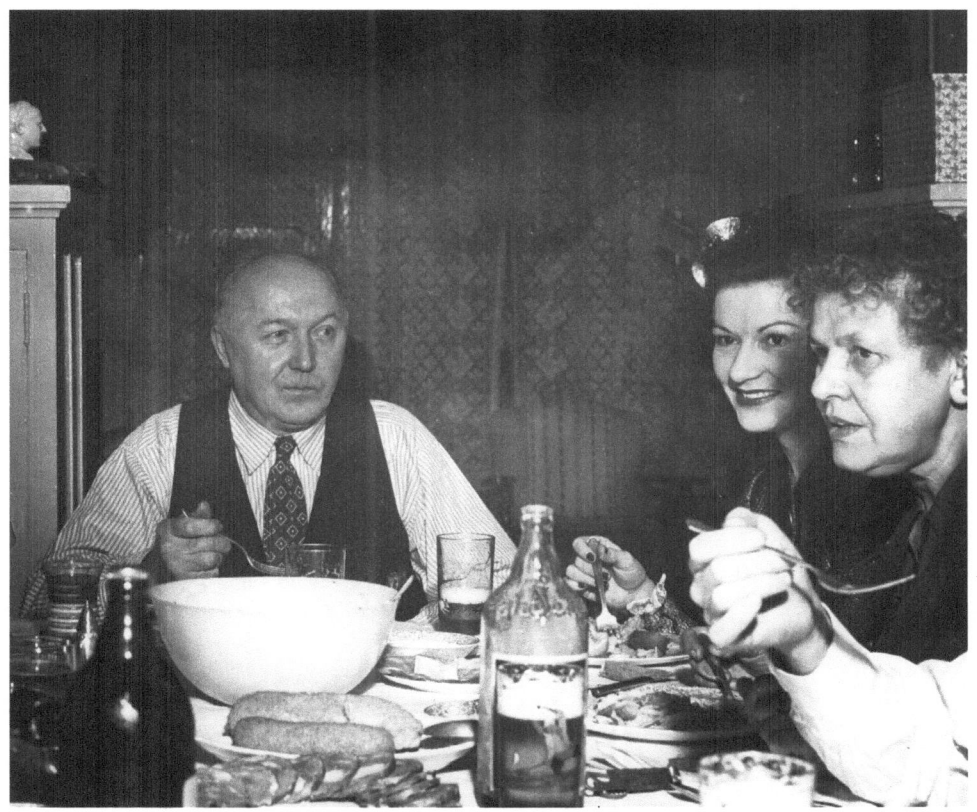

"Boss" holds court at Sunday dinner. (c1956)
(Blanche Mrazek, Harold's wife, sits on his left next to Ada Mrazek

In the last years of his life, Joseph Mrazek followed a regular weekend routine. It began on Friday evening after supper when he would listen to his favorite radio serials while smoking a succession of *Between the Acts* cigarillos. Except for the bitterest winter nights, he slept on his enclosed porch.

He spent Saturday mornings working in his studio, and the afternoons were reserved for the live radio broadcast from the Metroplitan Opera, hosted by his friend Milton Cross. On Sunday mornings, the Mrazek women would gather to prepare the weekly feast.

By 1959, Boss had lost the powerful, narrow-waisted gymnast's body of his youth to the rich diet he had favored throughout his life. He now walked with a cane. One afternoon, while strolling out to one of the porches, he tripped and fractured his hip.

Joseph Mrazek had a deep, unreasoning distrust of doctors. Although in great pain, he initially refused to go to the hospital. When his sons intervened to convince him that the hip needed to be properly set, he reluctantly agreed. When the ambulance came to take him to the hospital, he solemnly declared that he would never see his home again.

The prediction was accurate. While operating on his hip, one of the doctors, a Czech surgeon brought in by the family, failed to remove a metal clip from the surgical field. When Joseph failed to rally after the operation, his doctors were perplexed. A battery of tests failed to discern the reason for the lack of progress in his recovery. It was only when his leg became abscessed that the real problem was discovered. By then, it was too late.

The last time I saw my grandfather was a few days before he died. When my brother Jim and I entered his hospital room, I didn't recognize him. The incredible life force he had always emanated was gone.

I will always remember the little sign that rested on the wall above his work table in Centerport. It consisted of only three lines, but the words have always stuck in my memory. After his many triumphs and defeats, it was the philosophy Joseph Mrazek chose to live by.

Don't worry.
It won't last.
Nothing does.

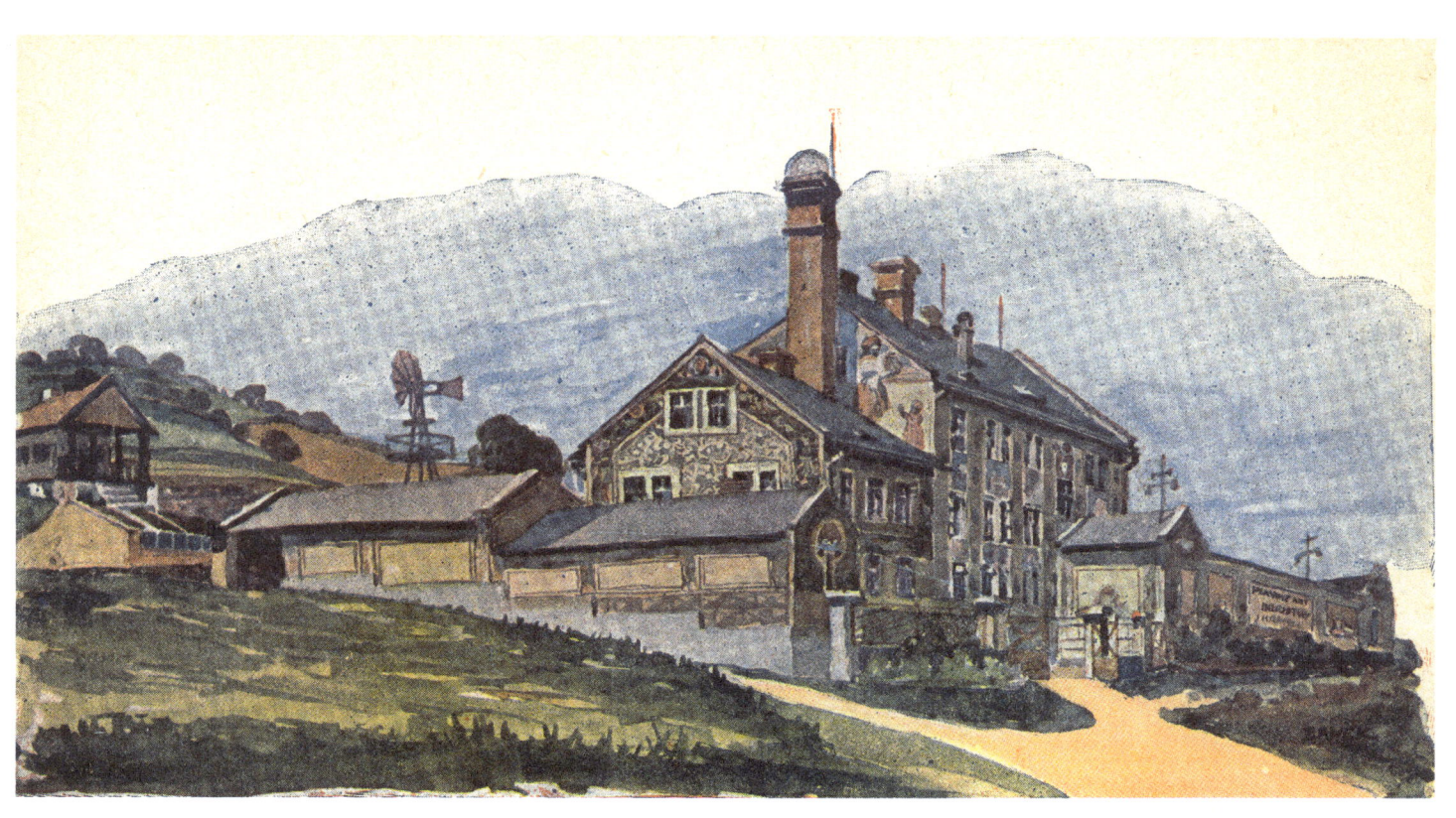
Watercolor painting of Mrazek factory in Letovice(c1926)

Joseph Mrazek's Pottery Process

Collectors of Joseph Mrazek's pottery might be interested to learn more about the process he used to create the nearly two hundred thousand hand-painted pieces manufactured at his principal factory in Letovice, Czechoslovakia.

The first step in the Mrazek pottery-making process began on the ground floor of the factory with the preparation of the clay, which was brought by truck from the nearby pits where it was being mined. The indigenous clay in this region of Moravia was of particularly high quality, with a rich cream color that required no bleaching or colorization.

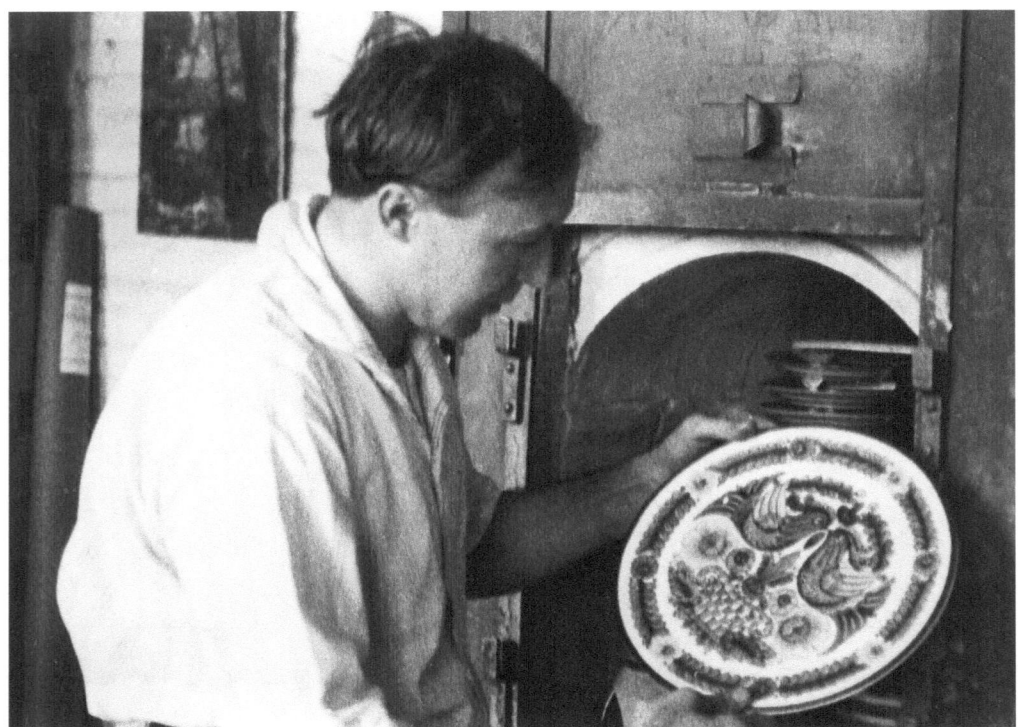

Joseph Mrazek at one of his smaller kilns in Letovice (c1923)

Until ready for processing, the clay was stored in huge metal containers in one of the three buildings in close proximity to the side of the factory. Two other outbuildings were utilized to store brown coal, which was used for firing the kilns, and black coal, which was used to heat the whole complex.

Once brought inside the factory, the raw clay was scooped into steel vats. Fresh water was slowly added, and the mixture continually stirred until it reached the consistency of heavy cream. The liquefied mixture was then pumped into a hydraulic press which stood seven feet high, twenty feet wide, and six feet in depth. Inside the press, a series of fine mesh screens removed all foreign substances as the compressive force was applied. The filtered end product of refined clay was then removed from the steel chambers like honey from a comb.

The refined clay was placed in sealed metal urns and transported to the work room that contained the factory's production molds. When Joseph Mrazek created a new shape for one of his pieces, his potters would use a foot-propelled spinning wheel at the work tables to create prototypes of the new piece. Once approved, these prototypes would serve as a "master" from which a series of production molds would then be cast. At least twenty molds would be made from each master.

Again liquefied, the refined clay would be injected into the production molds and set aside until it had set. After the set pieces were removed from the production molds, they were inspected for integrity, and refined to a perfectly smooth finish before being placed on rolling racks to be transported to the glazing room. There, the pieces were dipped in glaze and again allowed to dry.

The traditional lines of Mrazek pottery required two separate firings. The first firing took place in the massive kiln in the central area of the ground floor. This kiln stood eight feet high, and its four walls were each twelve feet long. Heat for the kiln was provided by four coal furnaces, set in the four walls. Observation holes made of eisenglass had been cut into the walls at a height of five feet. The entrance to the kiln was an opening six feet high and four feet wide. This opening was filled with bricks and sealed prior to the firing.

In the staging room next to the kiln, the pottery pieces were removed from the rolling racks and placed in large ceramic containers. Depending on their size, the containers held between six and twelve pieces of pottery. The ceramic containers were utilized to guarantee even heat to every piece, while providing an efficient way to maximize the firing space. There were no shelves inside, and the ceramic containers were stacked from floor to ceiling, with two inch spacers placed between each container to assure an even air flow.

Before the firing, four heat sensitive sensors were placed inside the kiln near the observation holes. Once

the prescribed degree of heat was maintained for the correct period of time, the sensors would soften and melt. This was the signal to bank the fires and allow the kiln to naturally cool. (An immediate influx of cold air would affect the product's durability.) The initial firing process usually lasted forty-eight hours, with temperatures exceeding 1000 degrees. Another twenty-four hours were required for the natural cooling process.

Once the firing was completed, the bricks covering the opening to the kiln would be removed, and the ceramic containers brought out. The pieces were removed from the containers and placed back onto the rolling racks to be transported upstairs to the decorating rooms. As soon as the huge kiln was emptied, another batch of ceramic containers was stacked inside and the procedure immediately repeated to keep downtime to a minimum.

In order to consistently achieve the striking and dramatic colors he desired, Joseph Mrazek had experimented with a wide range of pigments produced by manufacturers in Europe and the United States. The colors he finally purchased were manufactured by I. G. Farben & Co. They remained stable and true at all the firing temperatures he had chosen in his firing process.

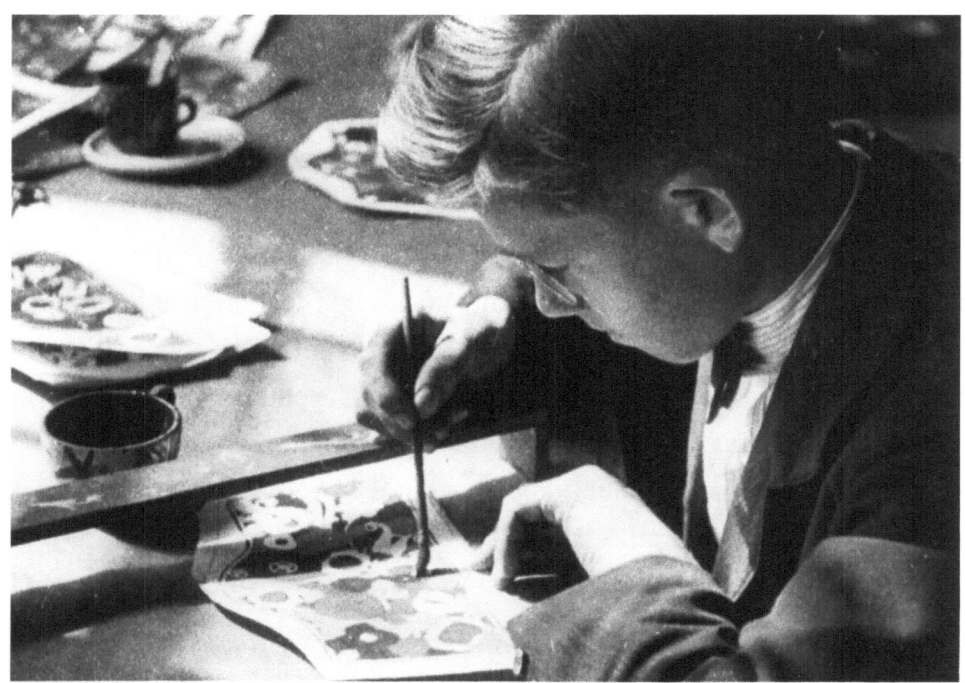

A young decorator practices his painting stroke (c1925)

The powdered colors also required careful refining before being used in the decorating process. In another ground floor room, a bank of circular drums rotated twenty-four hours a day. The drums were partially filled with stones, which slowly reduced both the pigments and the glaze to extra-fine powder. This was important because any remaining grainy material would appear on the surface of a finished piece like bits of sand. Once the refining process was completed, the colors and glaze were mixed with turpentine for use by the artists in the decorating rooms on the second floor.

Each line of Mrazek pottery had its own group of decorators, all of them trained to decorate their component of the whole before passing it along to the next artist. New decorators usually spent several weeks in training before Antonin Danek pronounced them ready to fulfill their role in the process.

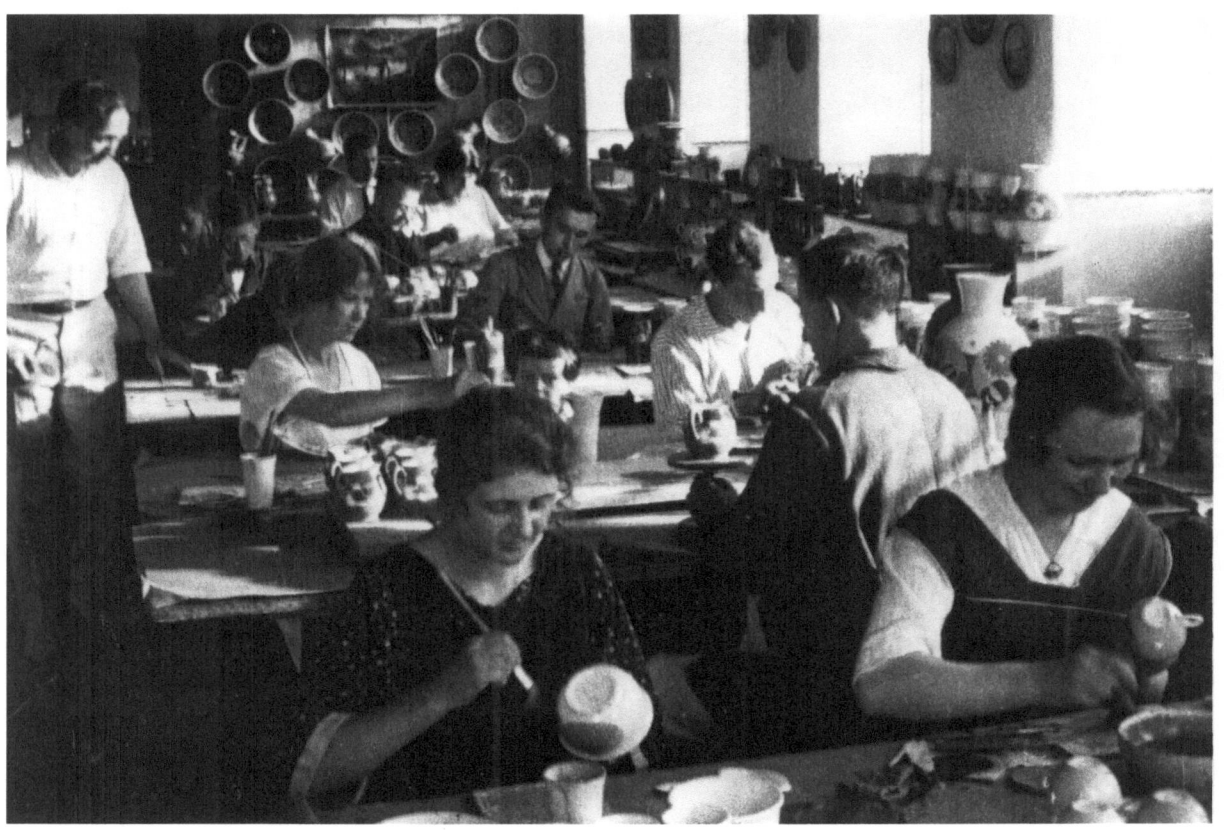

Joseph Mrazek, standing at left, supervises decorators (c1925)

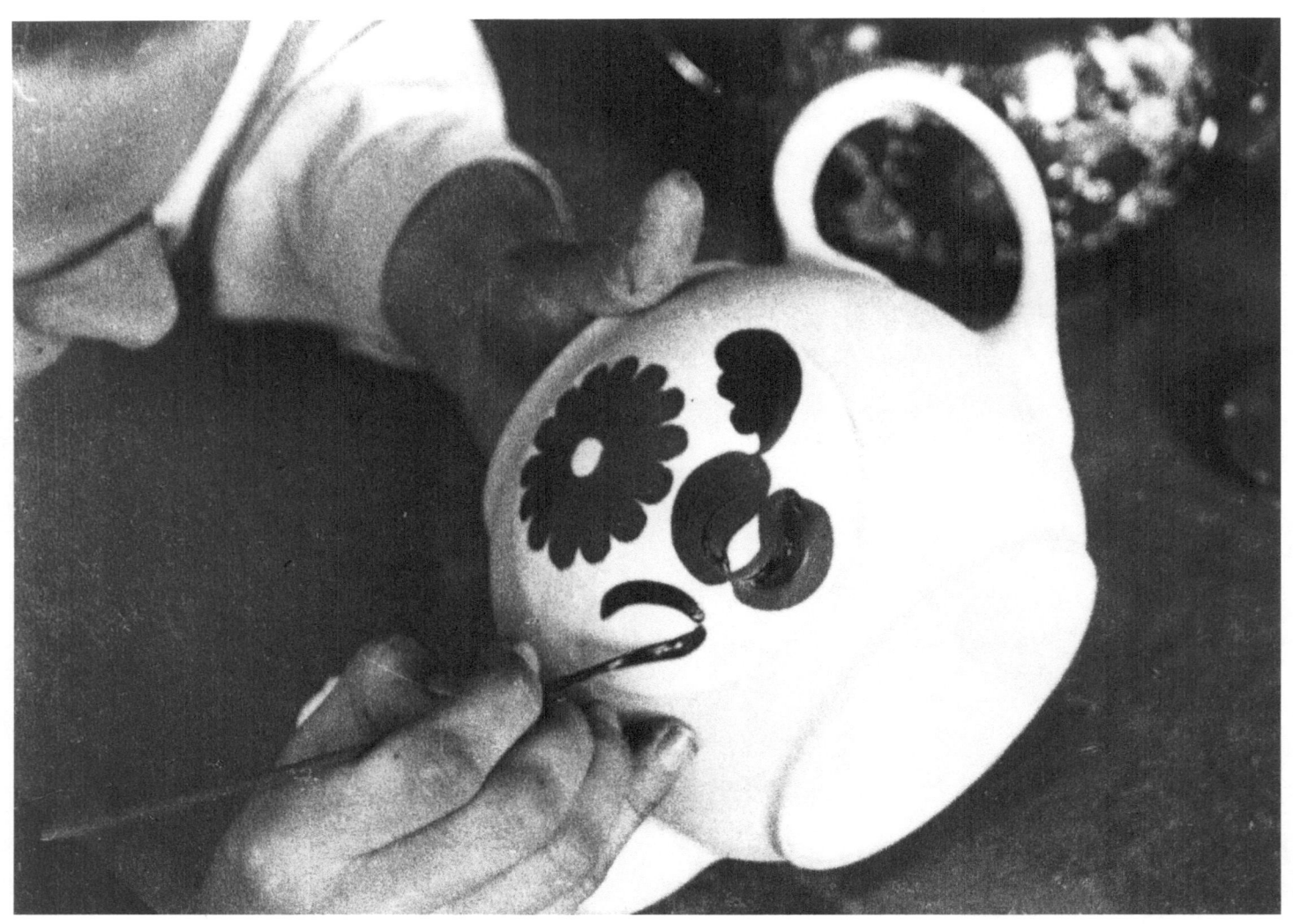

Antonin Danek demonstrates single brush strokes (c1925)

Once a piece was painted and glazed, it was set aside to dry on the rolling racks, after which the pieces were transported to a second bank of smaller kilns for the second firing process. Each of the smaller kilns had only one furnace.

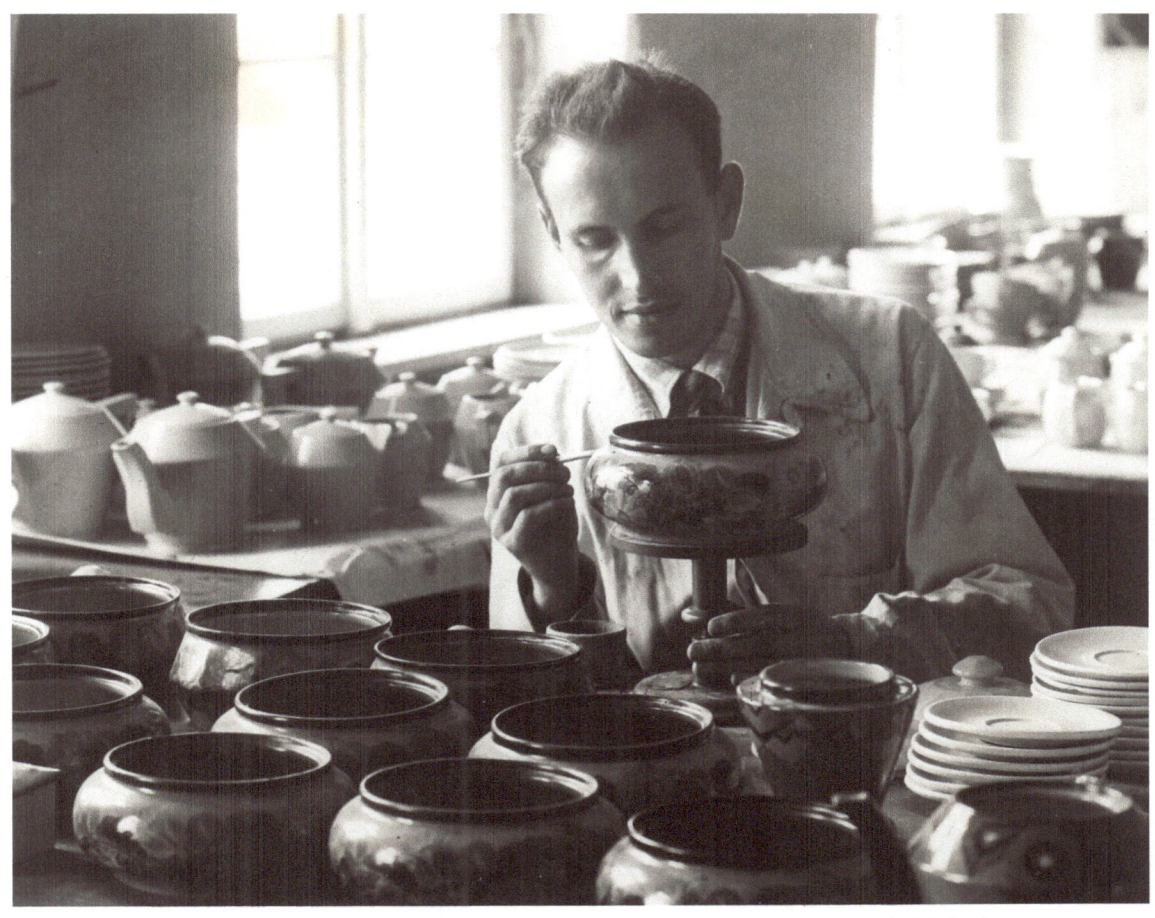
A senior artist finishes the decorating process (c1925)

 The second and final firing process operated on a three day cycle. Twenty-four hours were needed for the second firing, an additional day for cooling, and the third day for emptying and reloading.

 After the pieces were finished, a final inspection took place. The slightest fault would lead to a piece's destruction, but with the training the employees received, this was a rare occurrence. The last step in the process was to send the rolling racks to the large carpenter's shop, where each piece was carefully packed in straw and placed in large wooden crates for shipment to the United States.

The Mrazek Pottery Designs

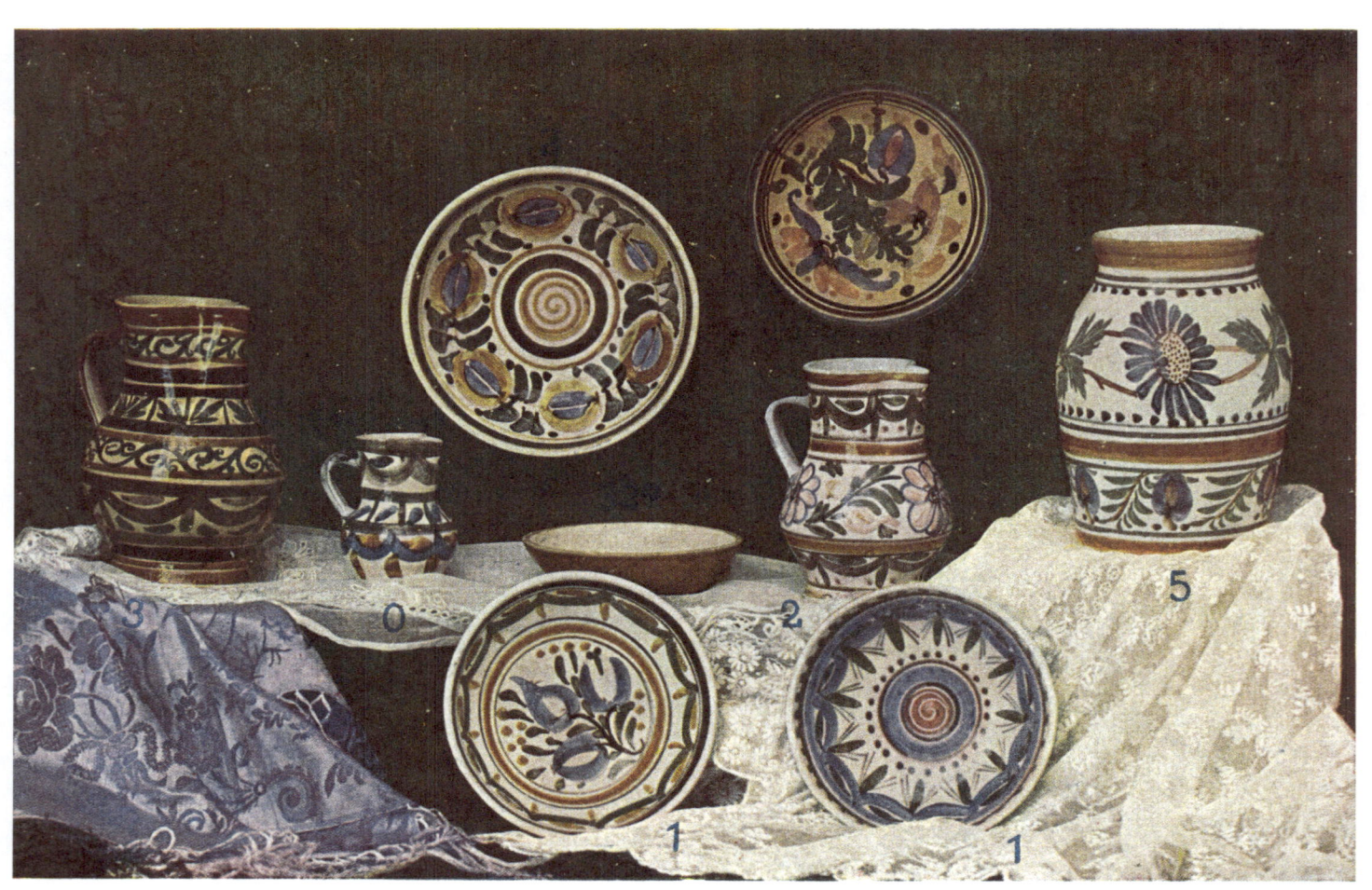

A selection of early Mrazek pottery designs (c1921)

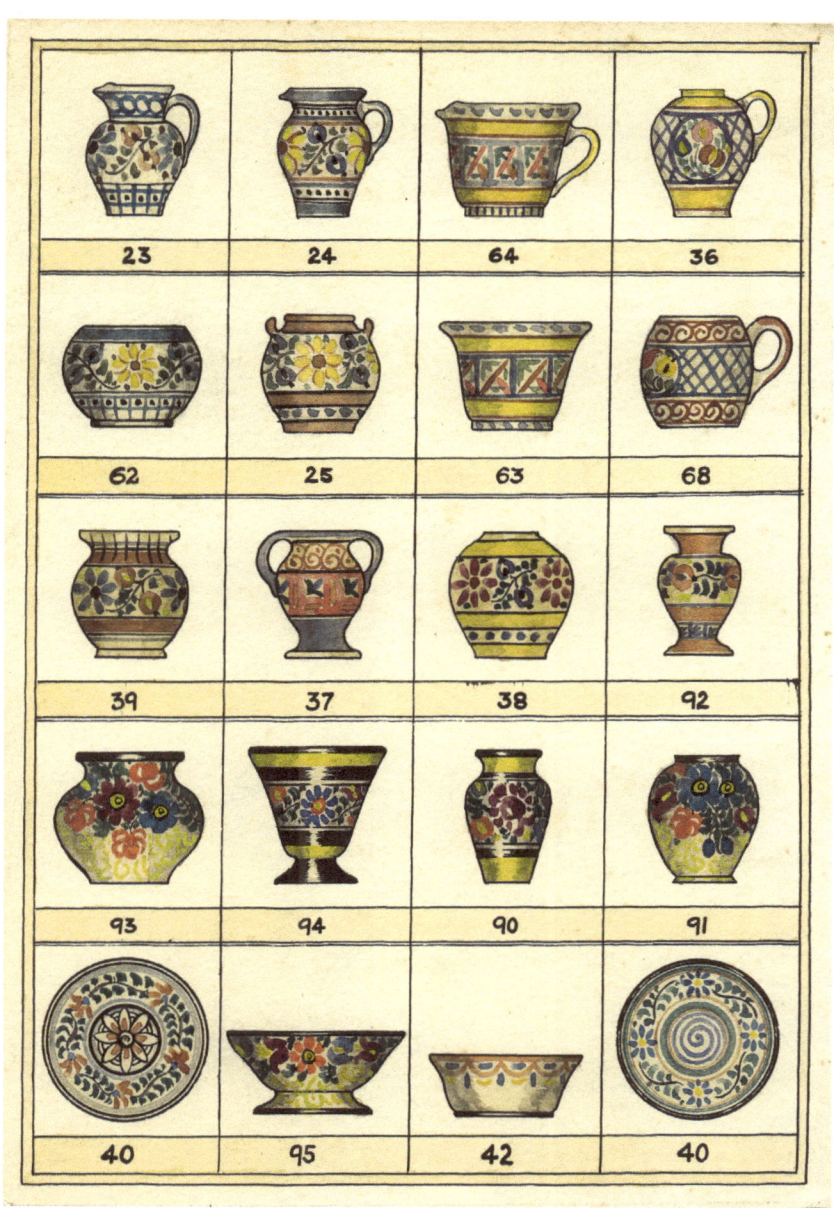

A page from an early Mrazek sales catalogue, displaying both designs and shapes (c1922)

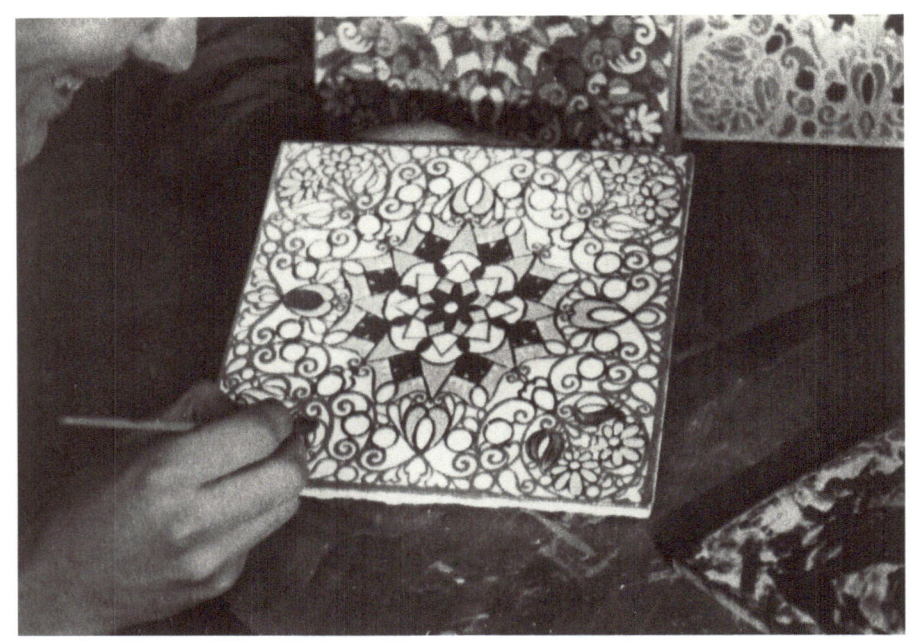

A Letovice artist paints a 6" square ceramic trivet

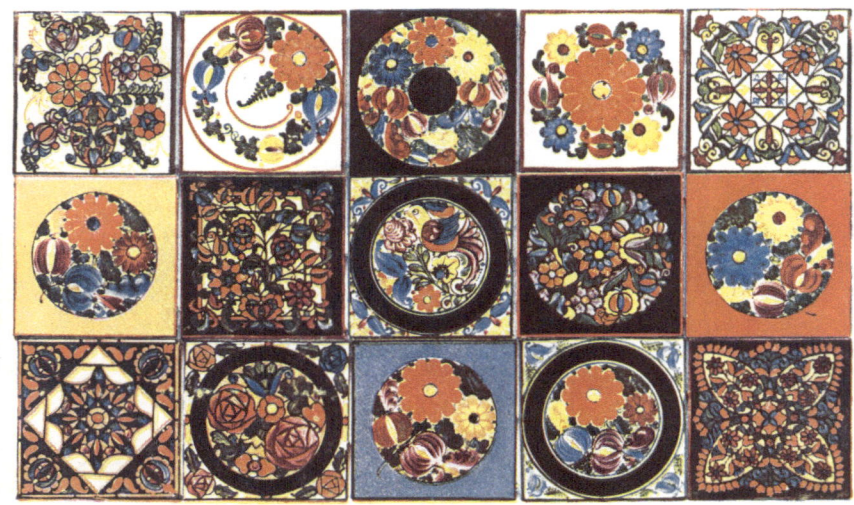

Fifteen designs of Mrazek trivets (c1924)

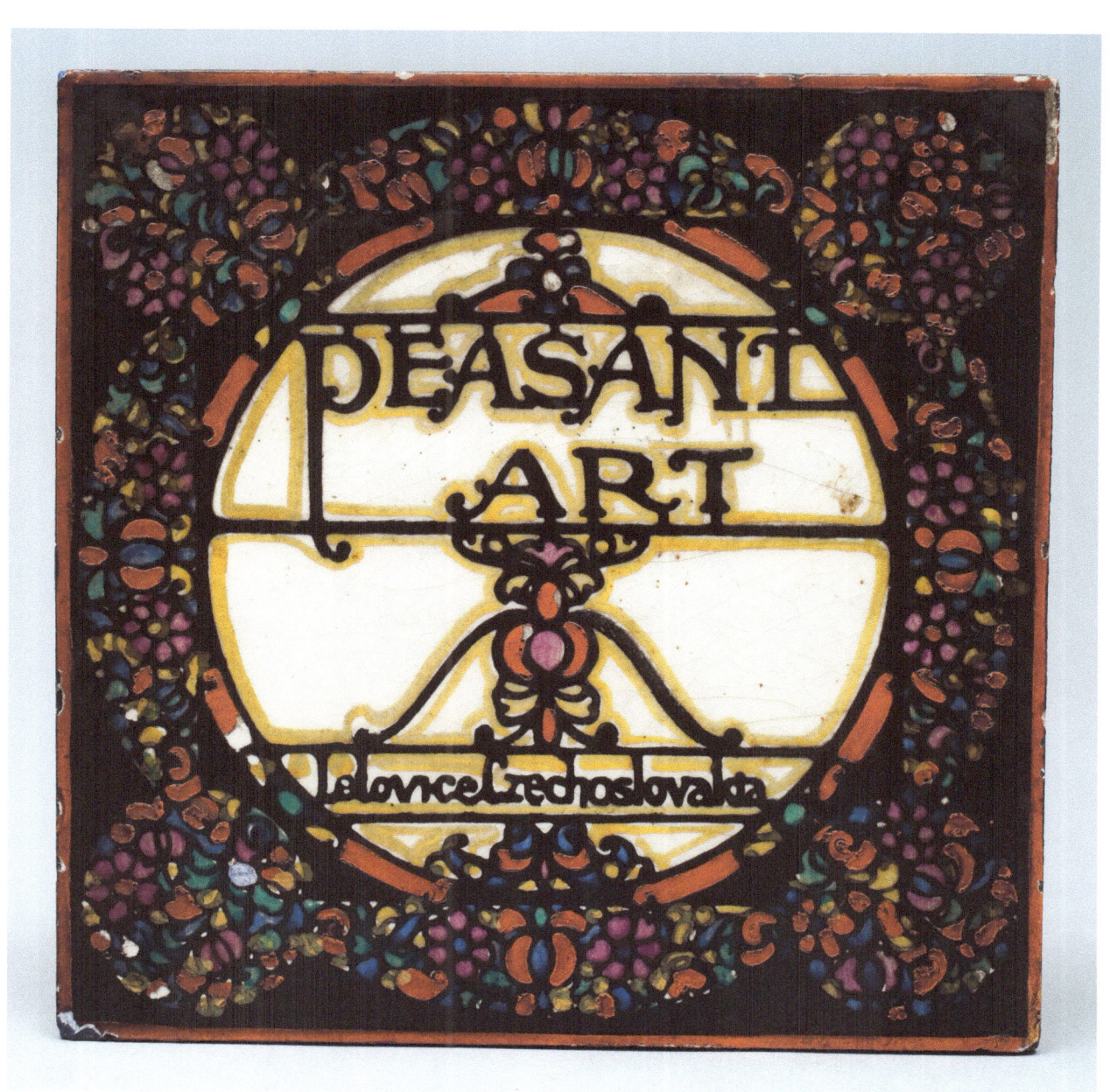

A trivet painted by Joseph Mrazek for the family (c1923)

Traditional Pottery Motifs

The following designs were based on the bold and colorful embroideries sewed by Czech and Slovakian peasants. They include the daisy, the apple, the bleeding heart, the tulip, and numerous other symbolic peasant designs.

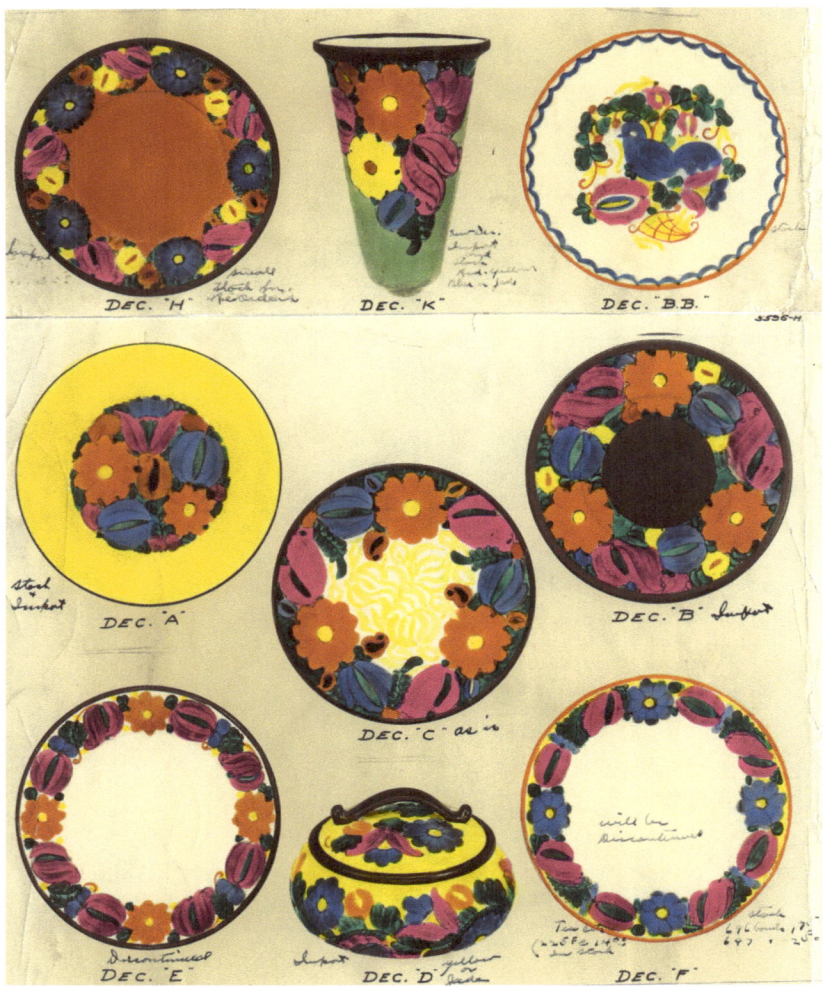

A selection of traditional motifs in many colors (c1922)

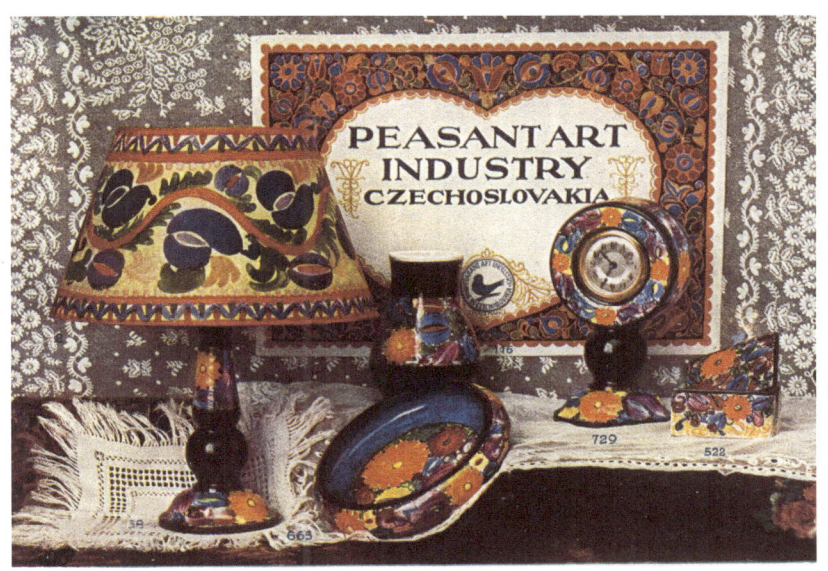

Cover picture in Mrazek pottery catalogue (c1924)

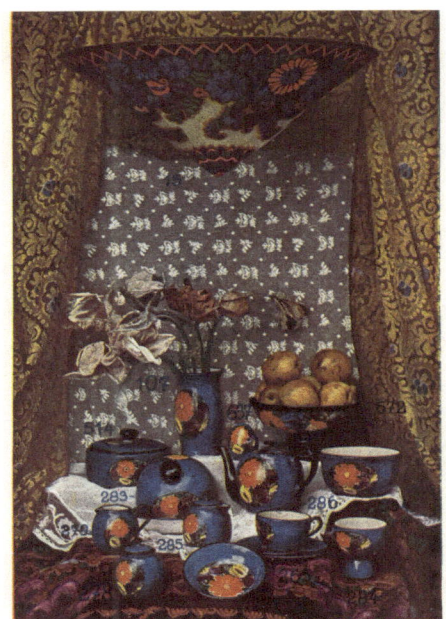

Blue pattern in Mrazek pottery catalogue (c1924)

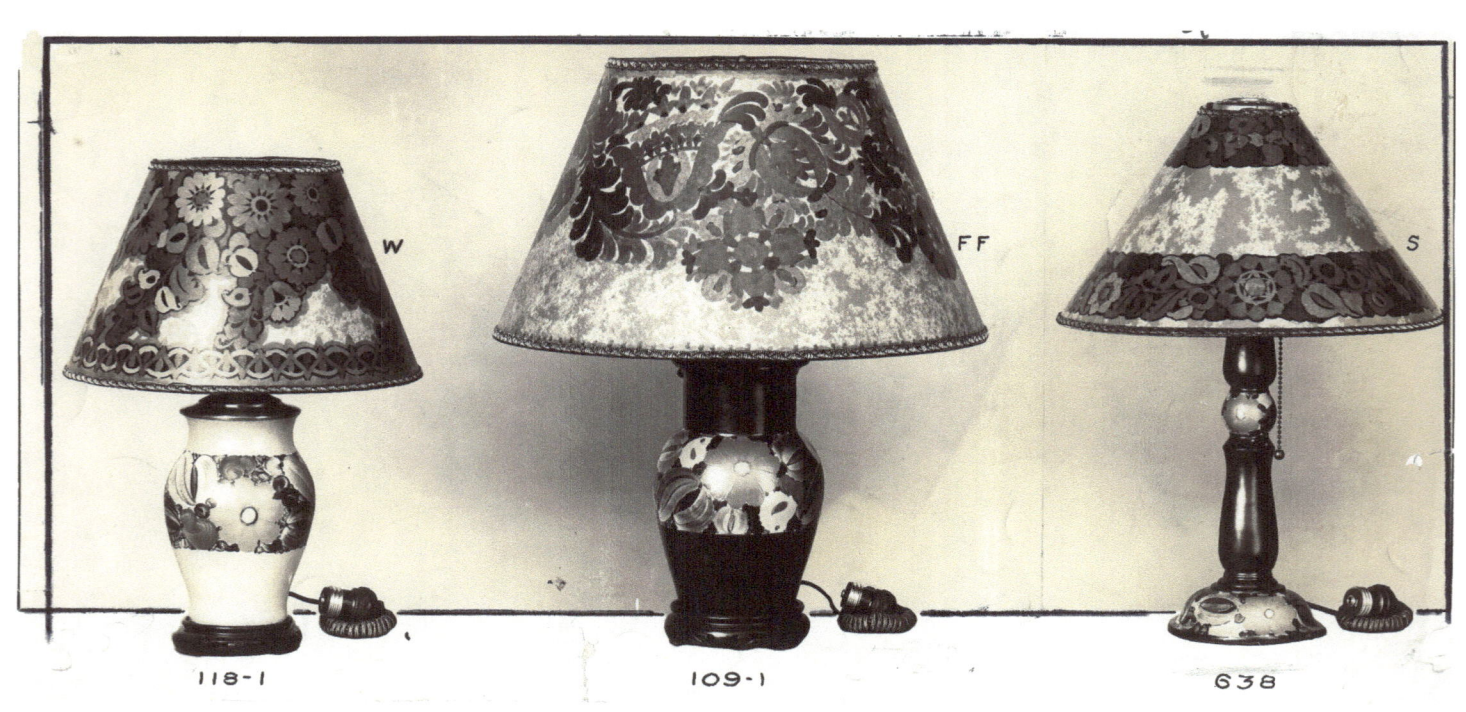

Three Mrazek lamps and hand-painted shades (c1924)

The Cubist Period (Art Deco)

The cubist patterns reflected the influence on Joseph Mrazek of Frantisek Kupka (1871-1957) and other European surrealists. Kupka was a Czech painter and graphic artist who was an early pioneer of the abstract art movement. Joseph Mrazek greatly admired his work.

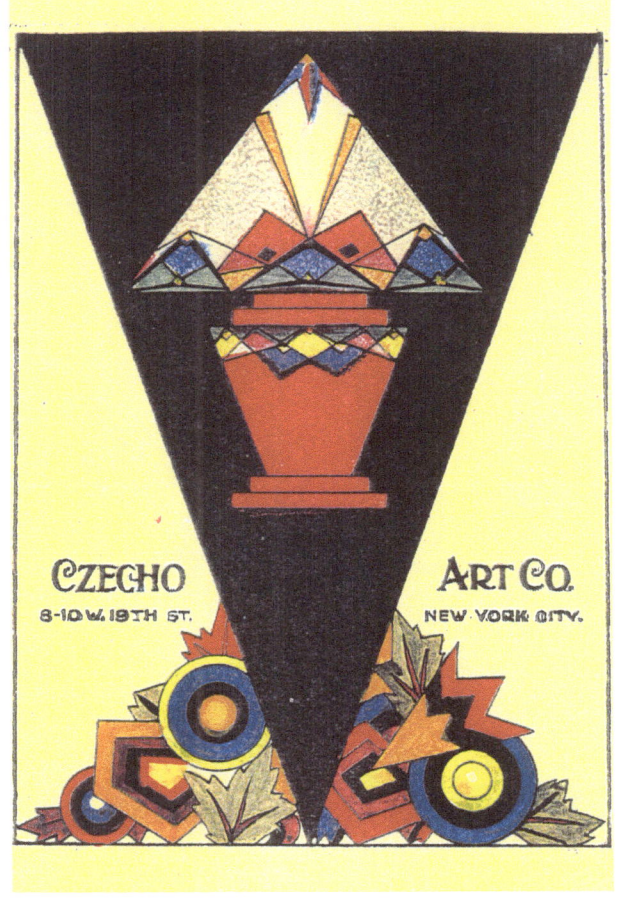

**The cover page of Joseph Mrazek's cubist catalogue,
red lamp base planted in an art deco garden**

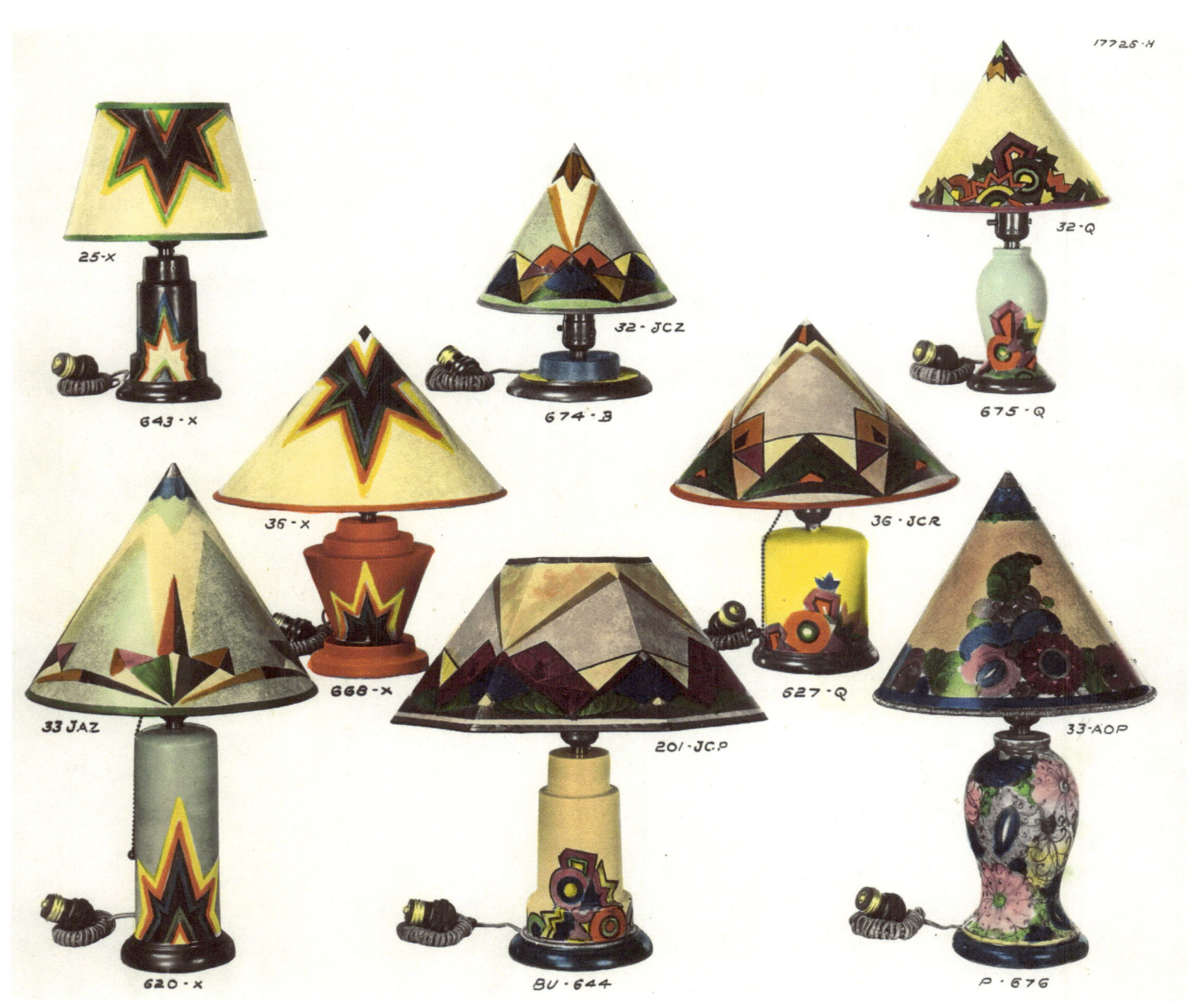

A selection of cubist-patterned lamps and shades (c1926)

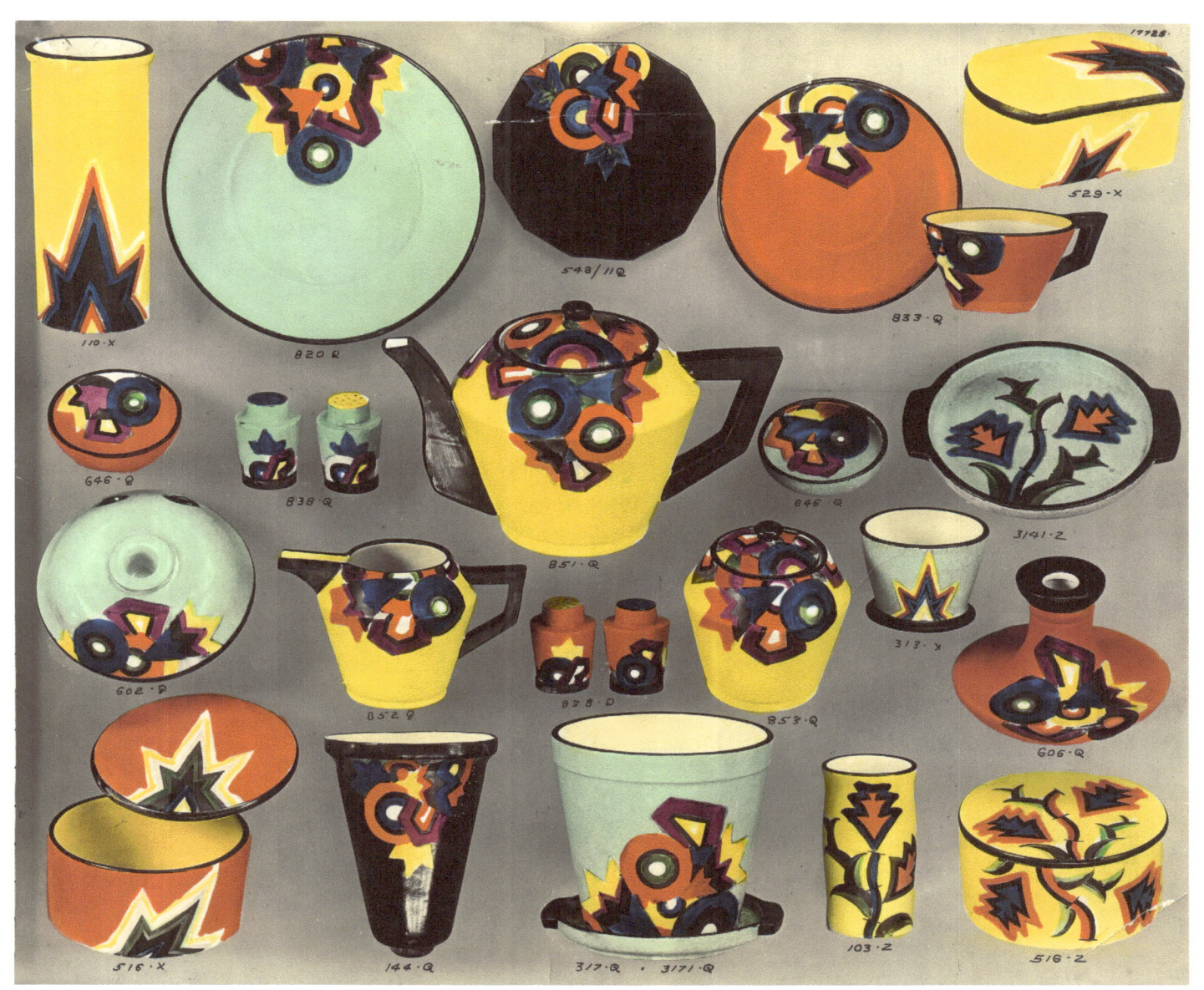

A selection of cubist-patterned pottery (c1926)

Joseph Mrazek's Artistry: An Appreciation

In his "traditional" pottery lines, Joseph Mrazek employed three distinct designs. They included *Medallions*, *Bands*, and *Figure/Grounds*. Medallions and the Bands can be easily interpreted. The Figure/Ground is very important to understanding his pottery.

All art begins with a figure painted on a background. From the dawn of civilization, when our primitive ancestors used charcoal to chalk their designs on the wall of a cave, there has always been an object and a background, the *figure* and the *ground*.

One of the important advances in human perception related to art was the realization that the ground can be designed and controlled as completely as the figure. When an artist has both figure and ground under control, and when he gives equal attention to both challenges, it leads to a combination in which neither dominates. Both are expressive, and both contribute to the beauty of the design. Joseph Mrazek understood the principle of figure/ground, and his work reflects a mastery of it in many of his pieces.

On the following pages, we present representative samples from the Mrazek family collection, many of which illuminate the traditional designs, as well as his later work. This in no way represent the full array of shapes and designs created by Joseph Mrazek from 1918-1931.

Figure/Ground Pieces

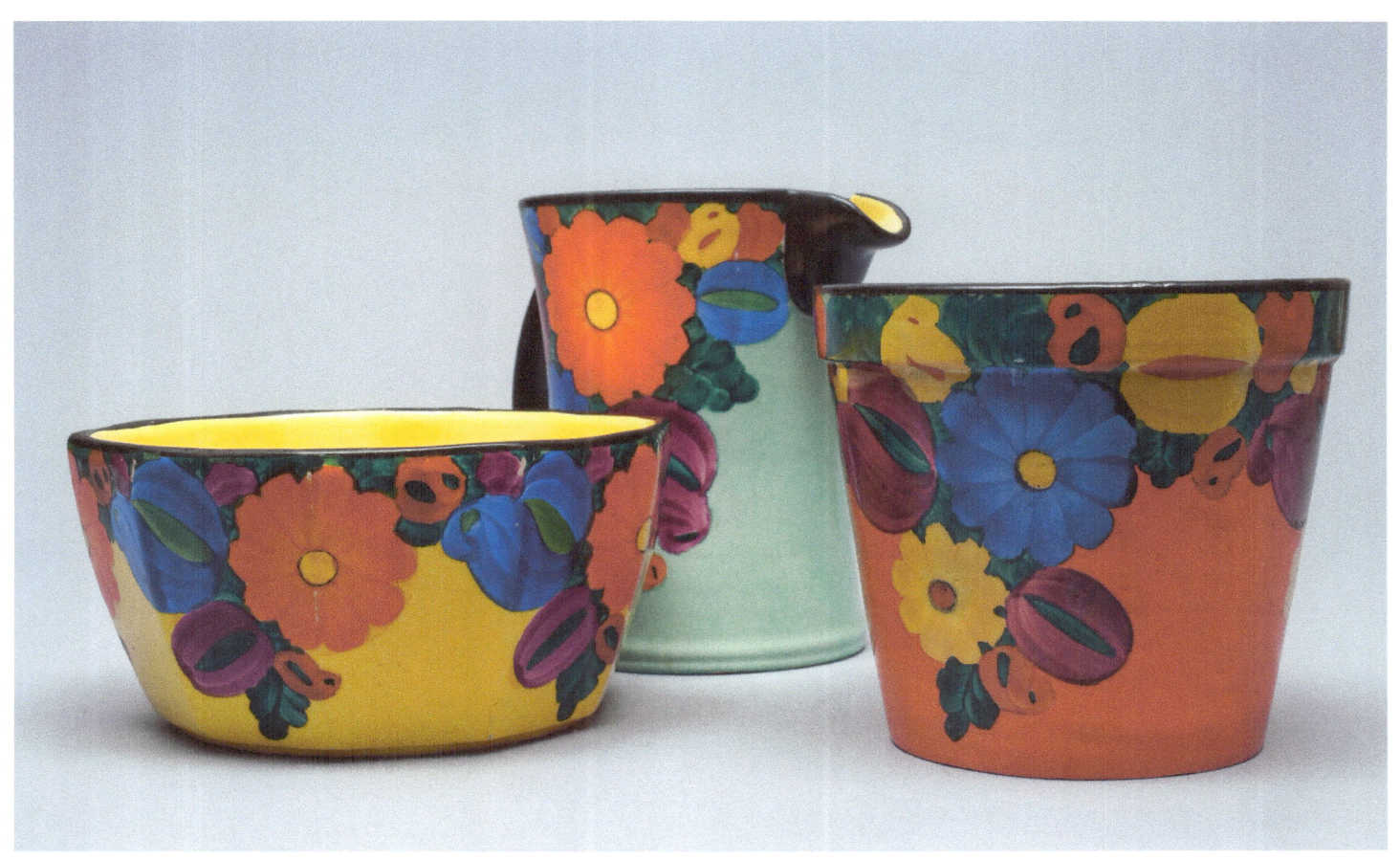

Three Piece Mixed Ensemble
(Pitcher) H 7" W 7"

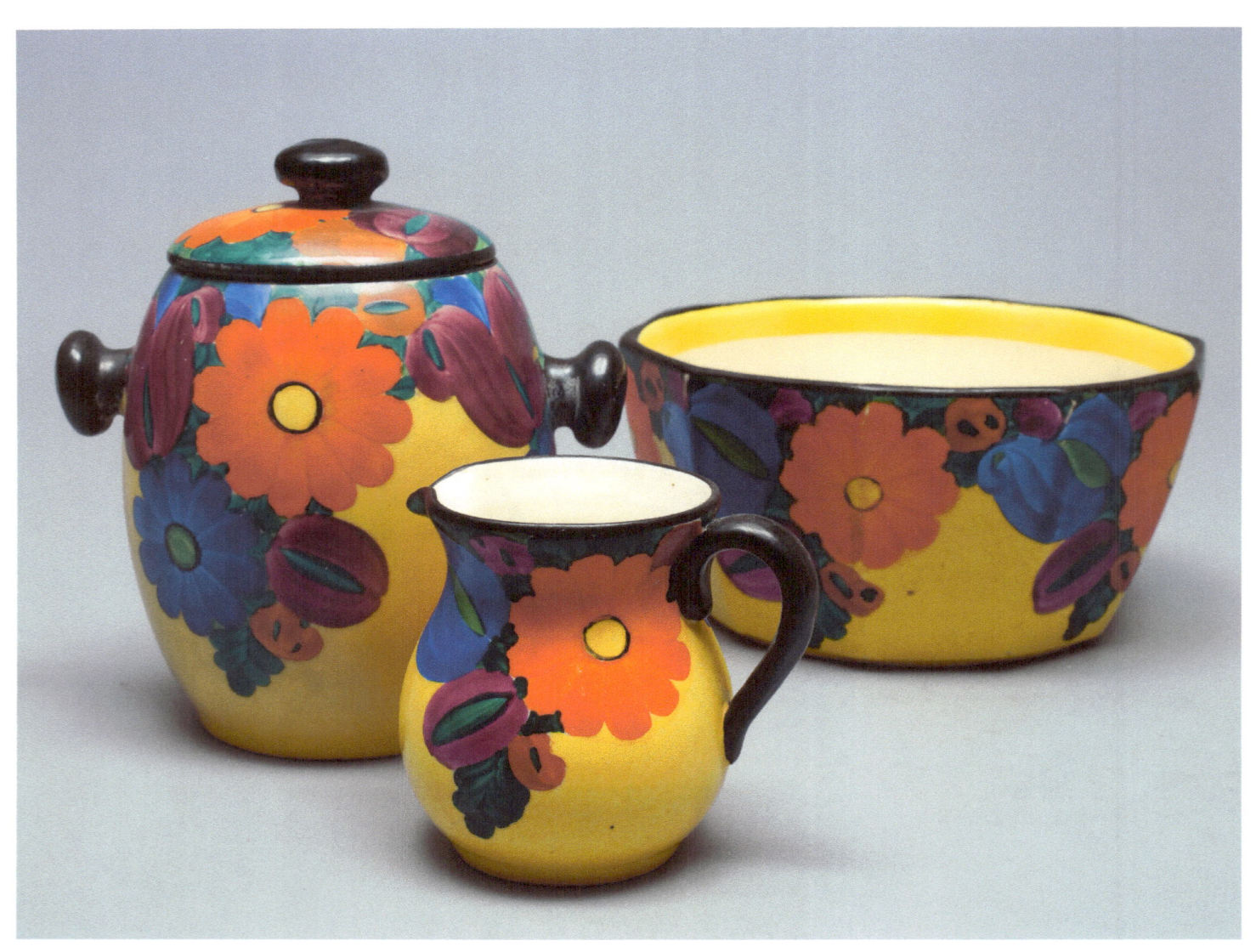

Three Piece Yellow Ensemble
(Bowl) H 4" W 8"

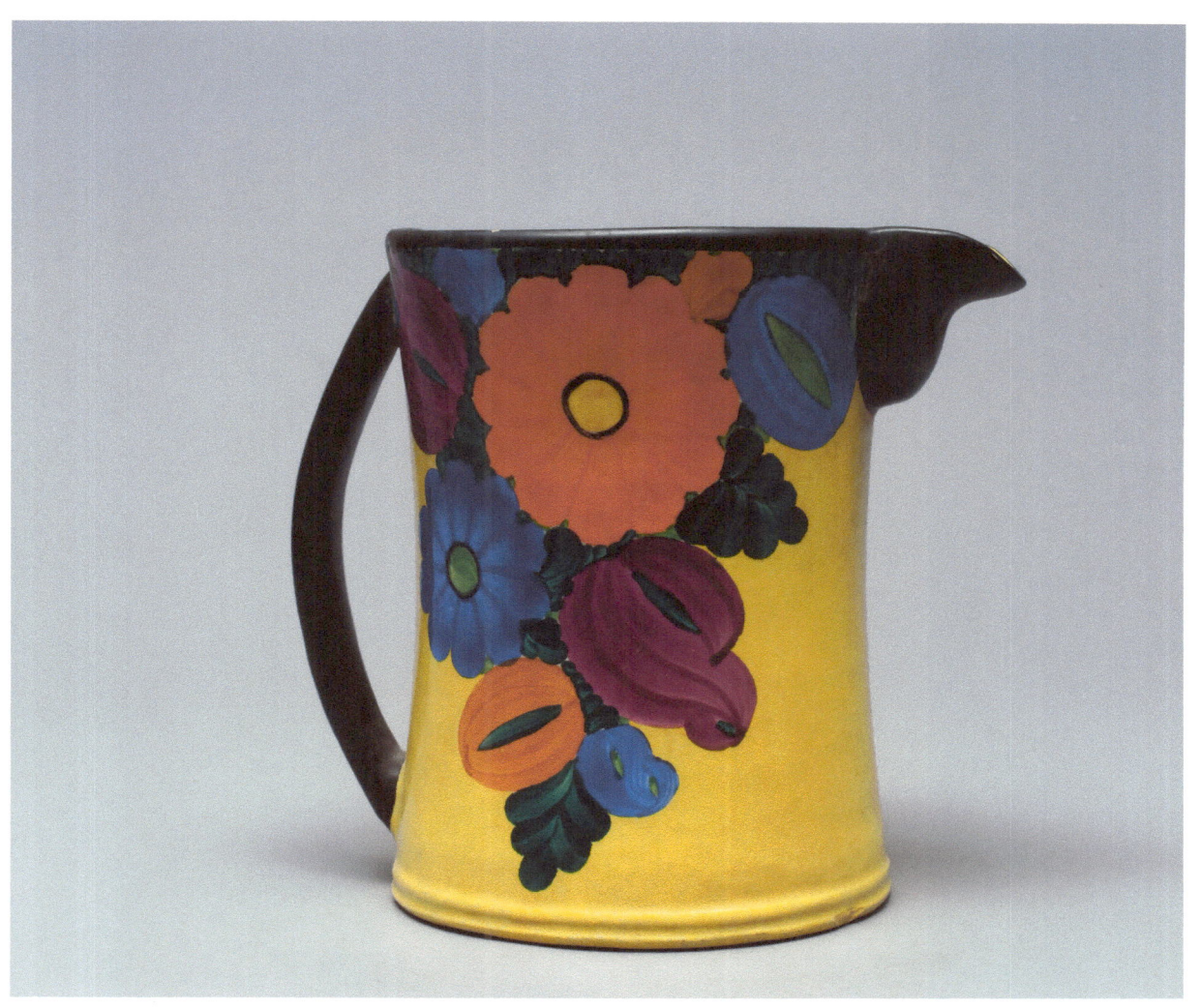

Large Yellow Pitcher
H 7" W 7"

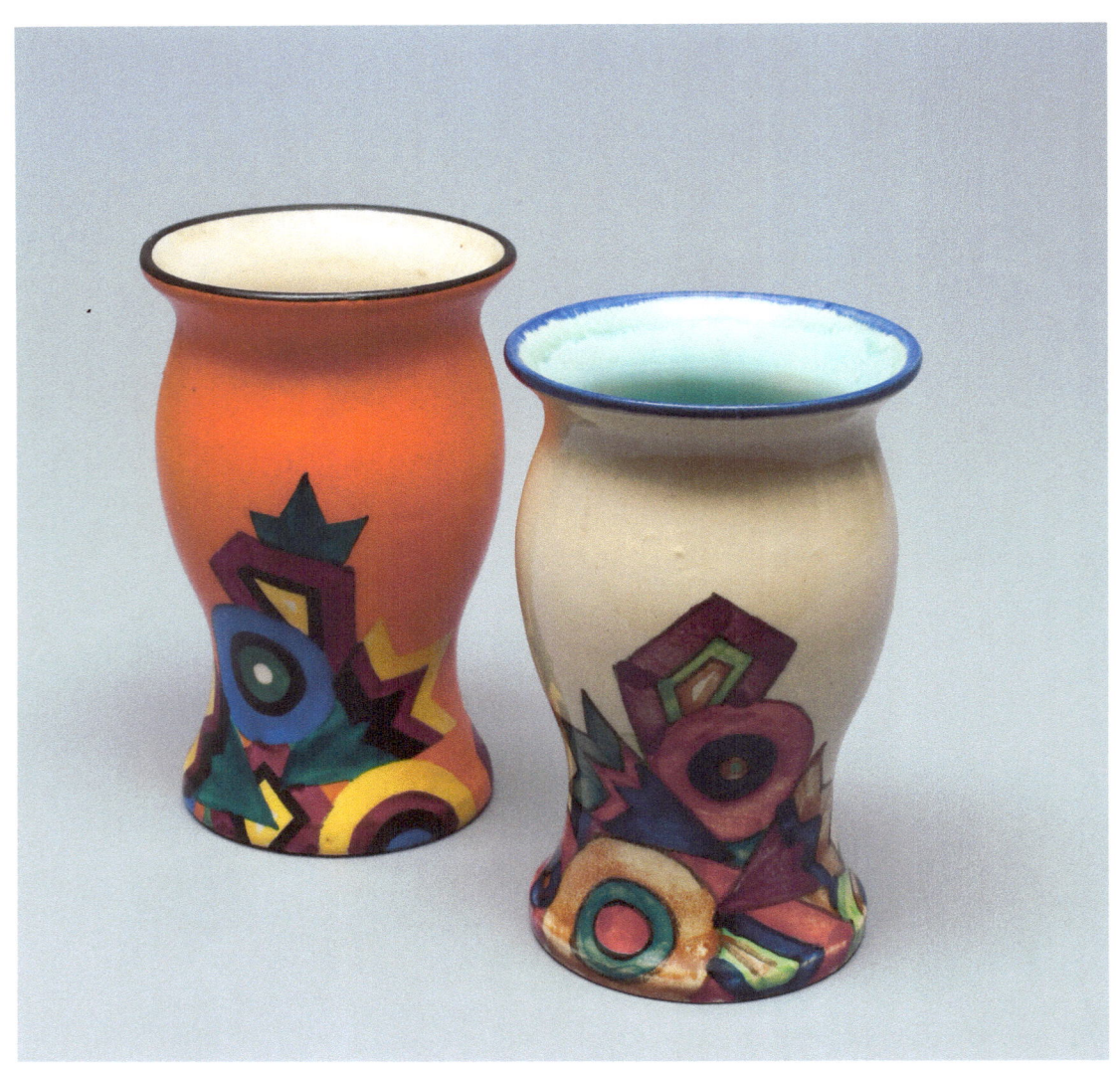

Two Cubist Vases
H 6 1/2" W 4"

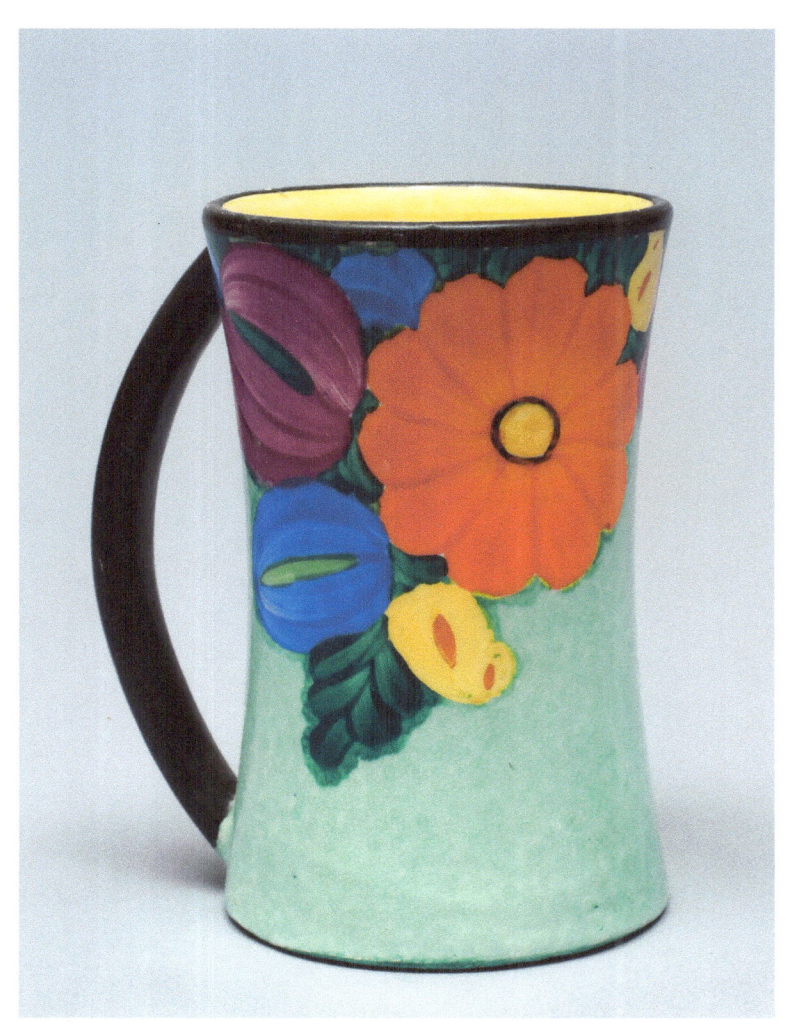

Green Mug
H 5" W 4"

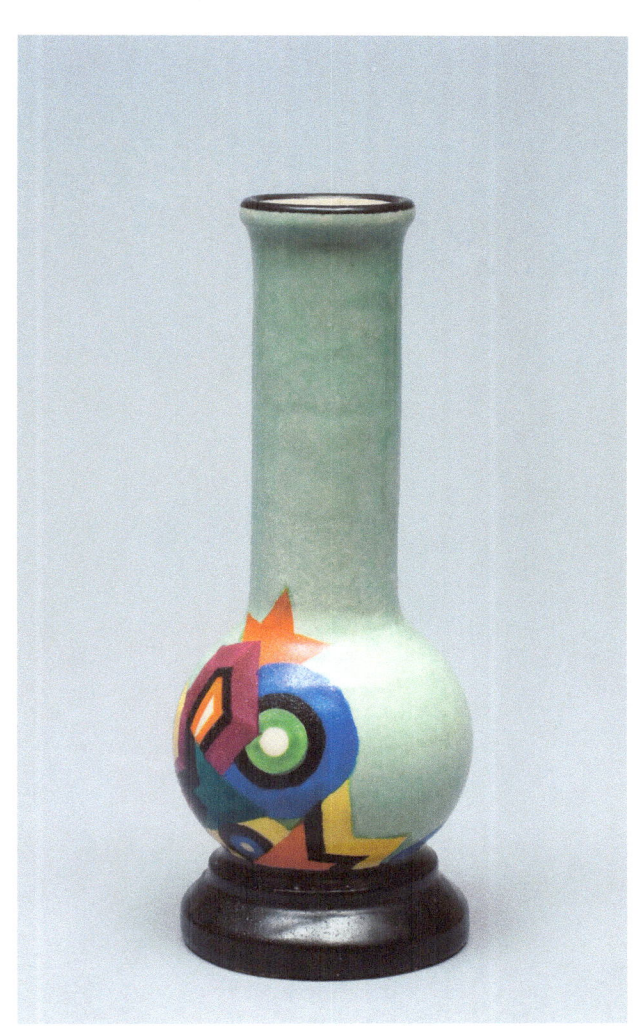

Cubist Vase
H 8" W 3"

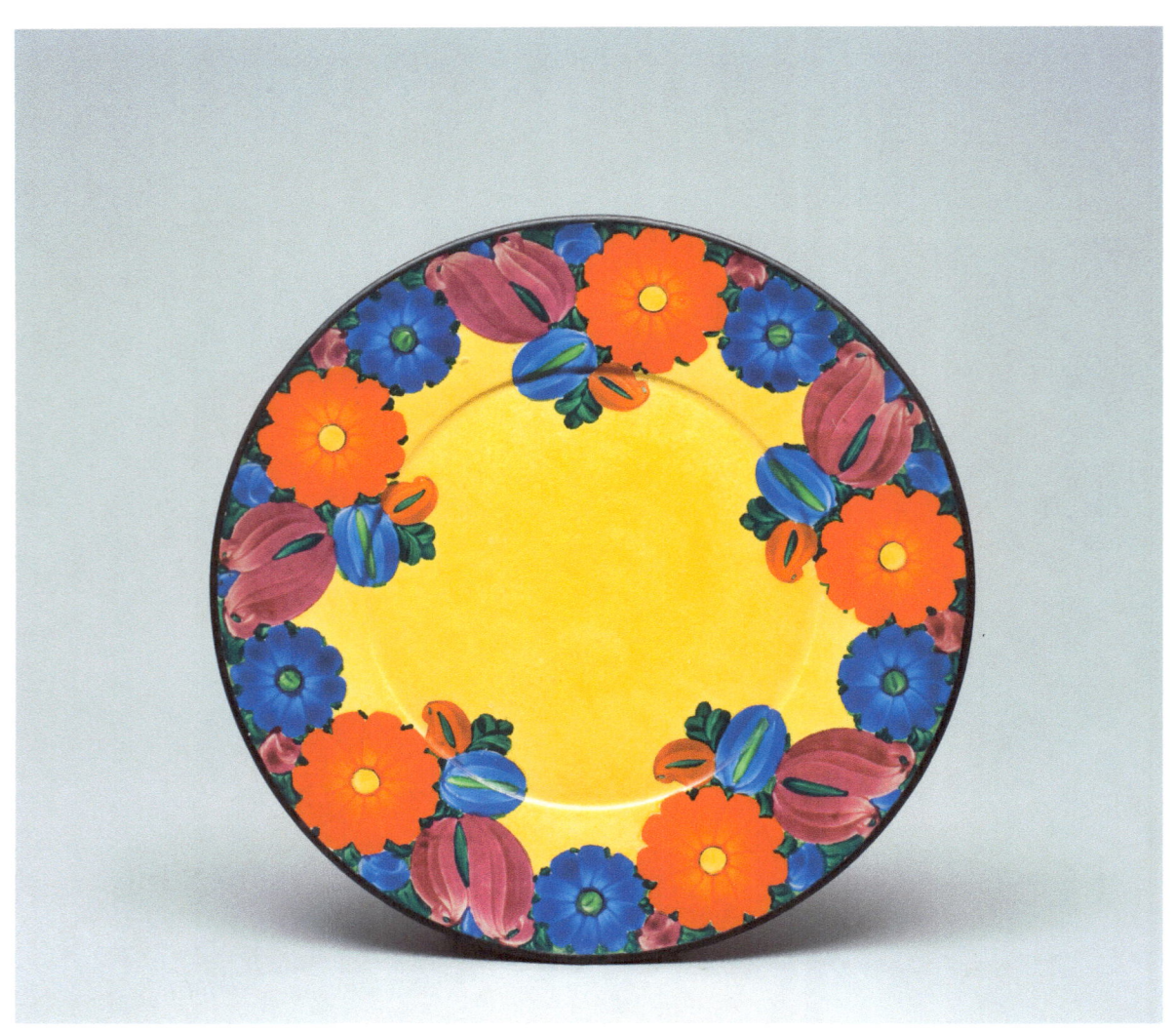

Serving Plate
13" diameter

Medallion Pieces

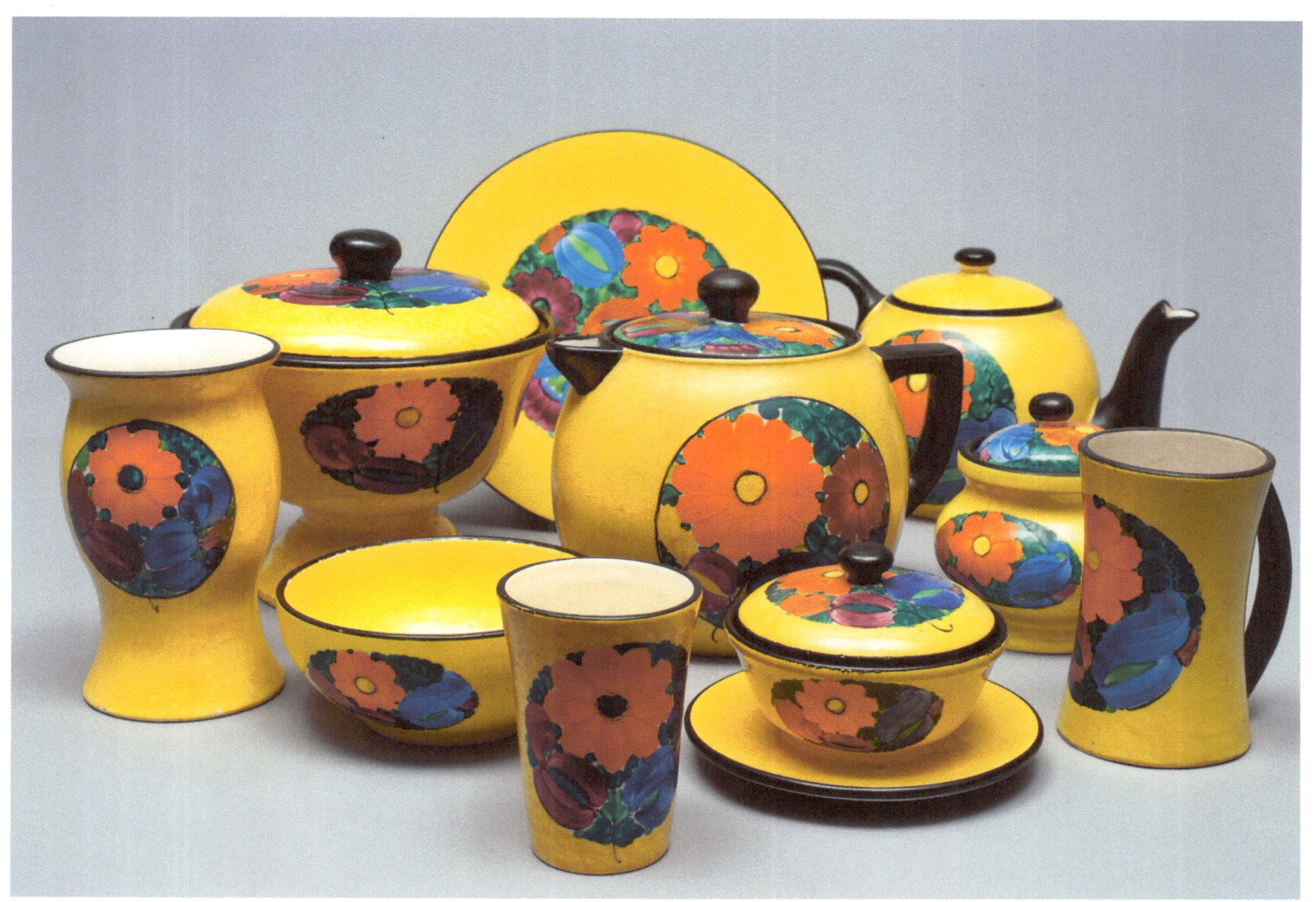

Yellow Ensemble

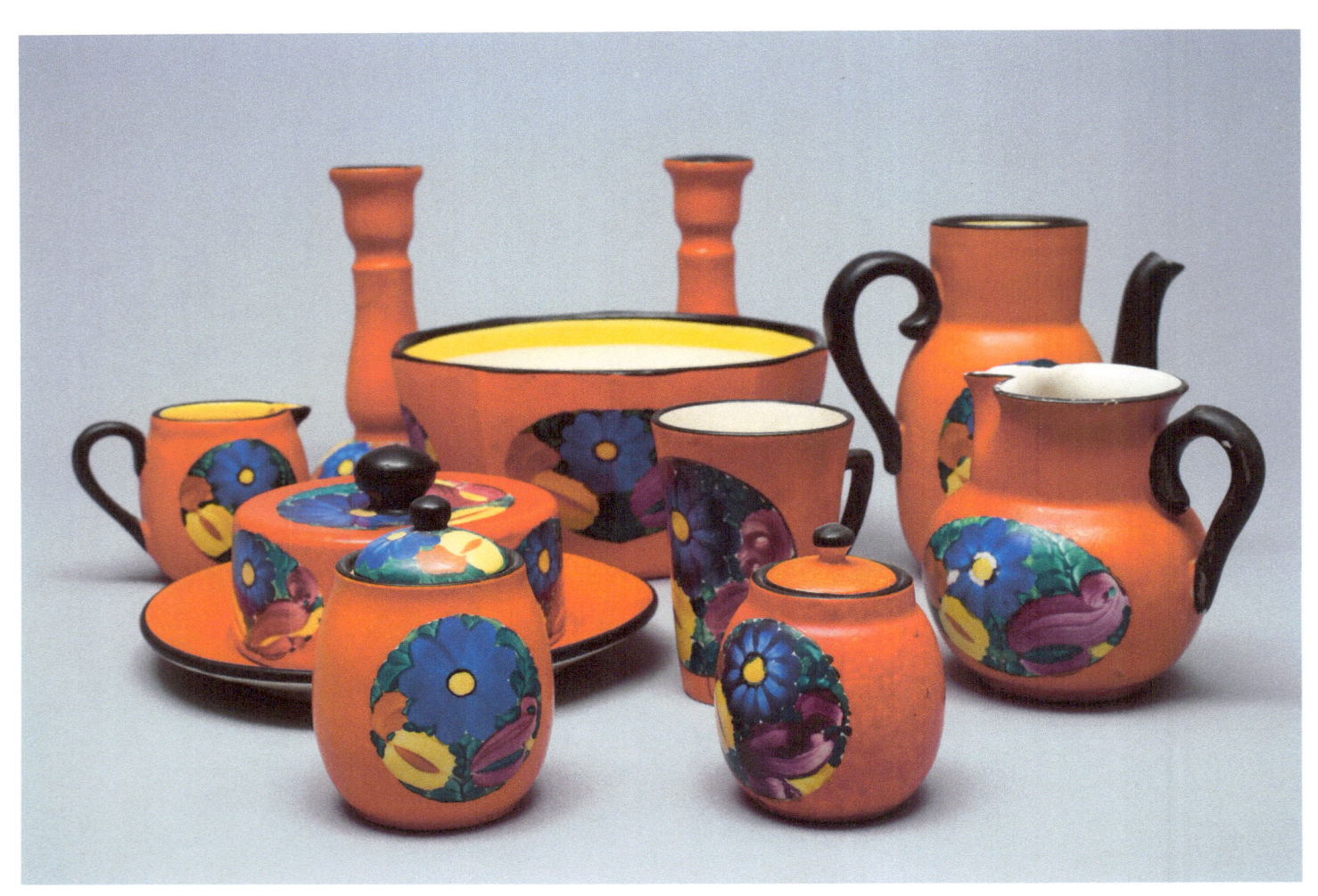

Orange Ensemble

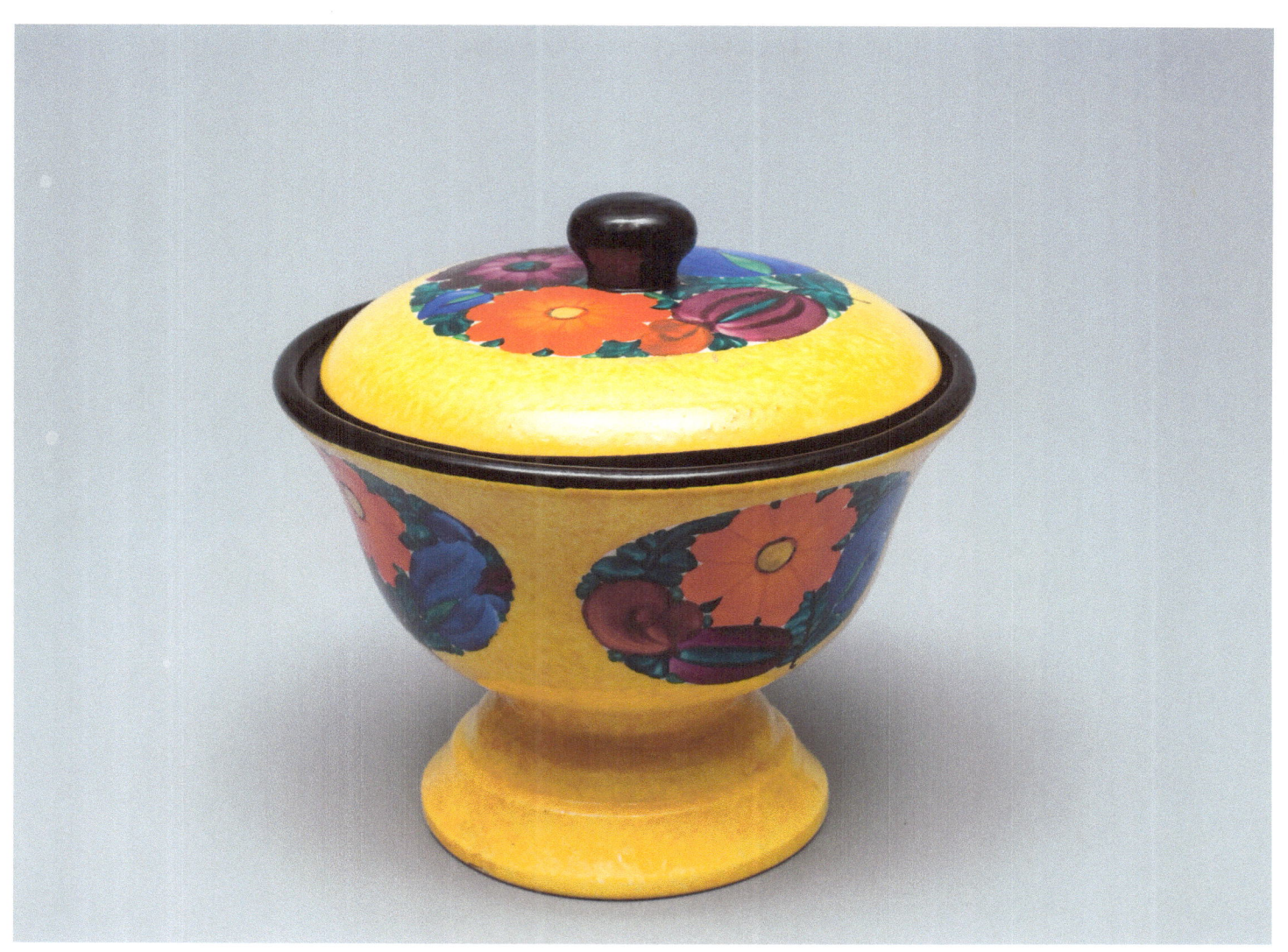

Yellow Compote
H 8" W 8"

Banded Pieces

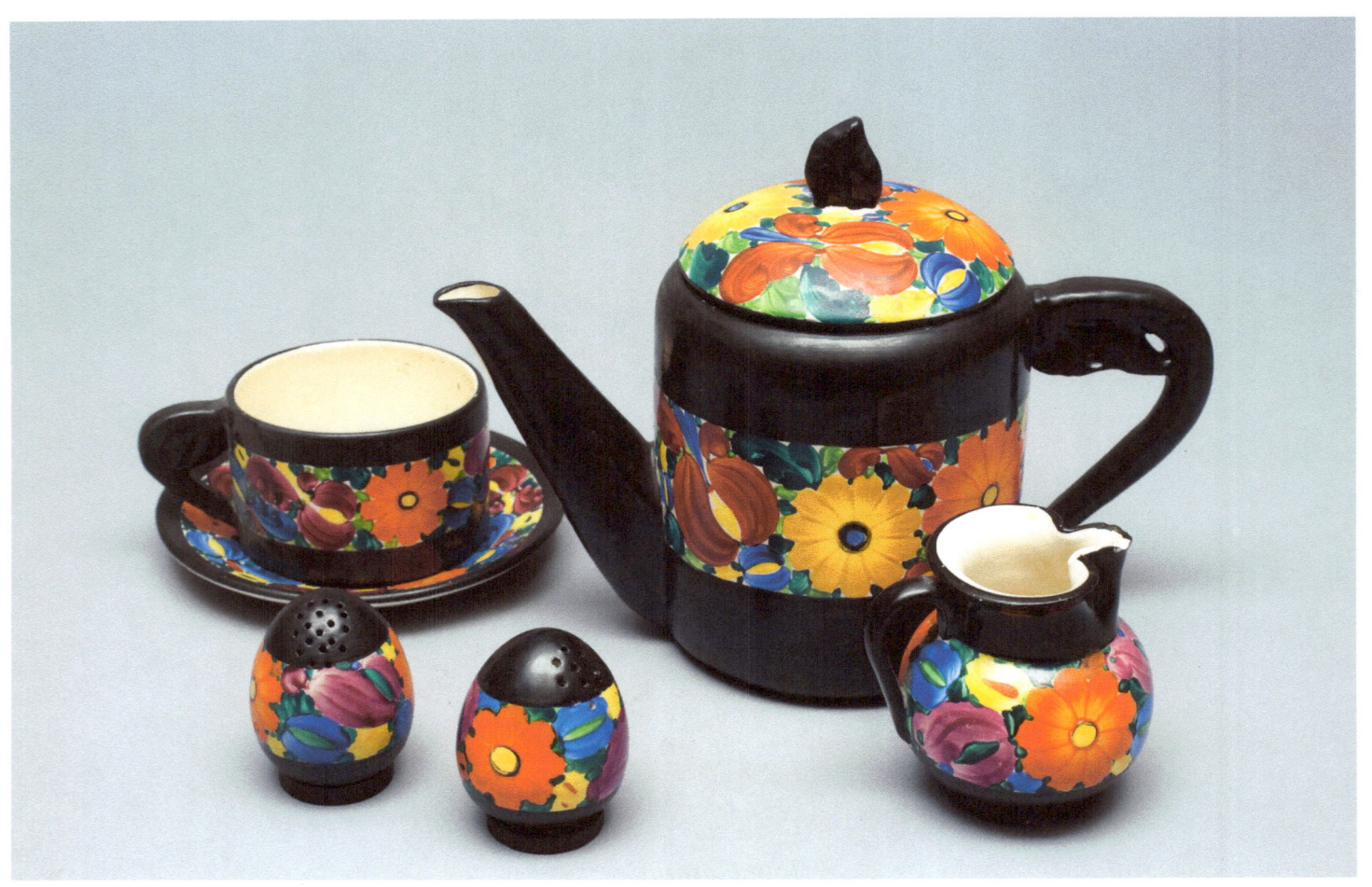

Black ensemble
(Teapot) H 8" W 9"

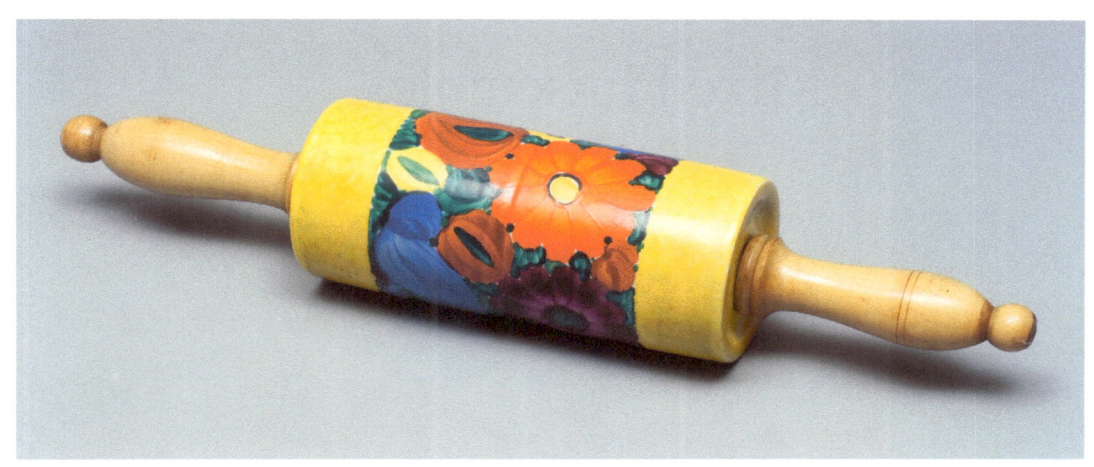

Yellow rolling pin
H 4" W 7"

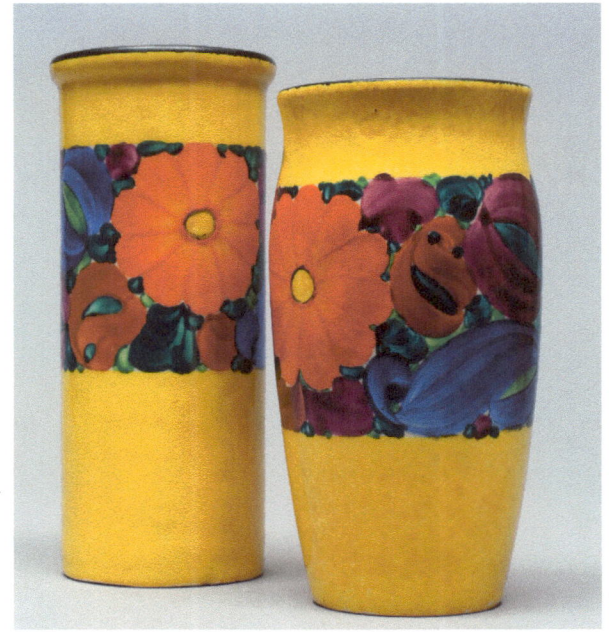

Two vases
Left vase) H 7" W 3"

Mixed Ensembles

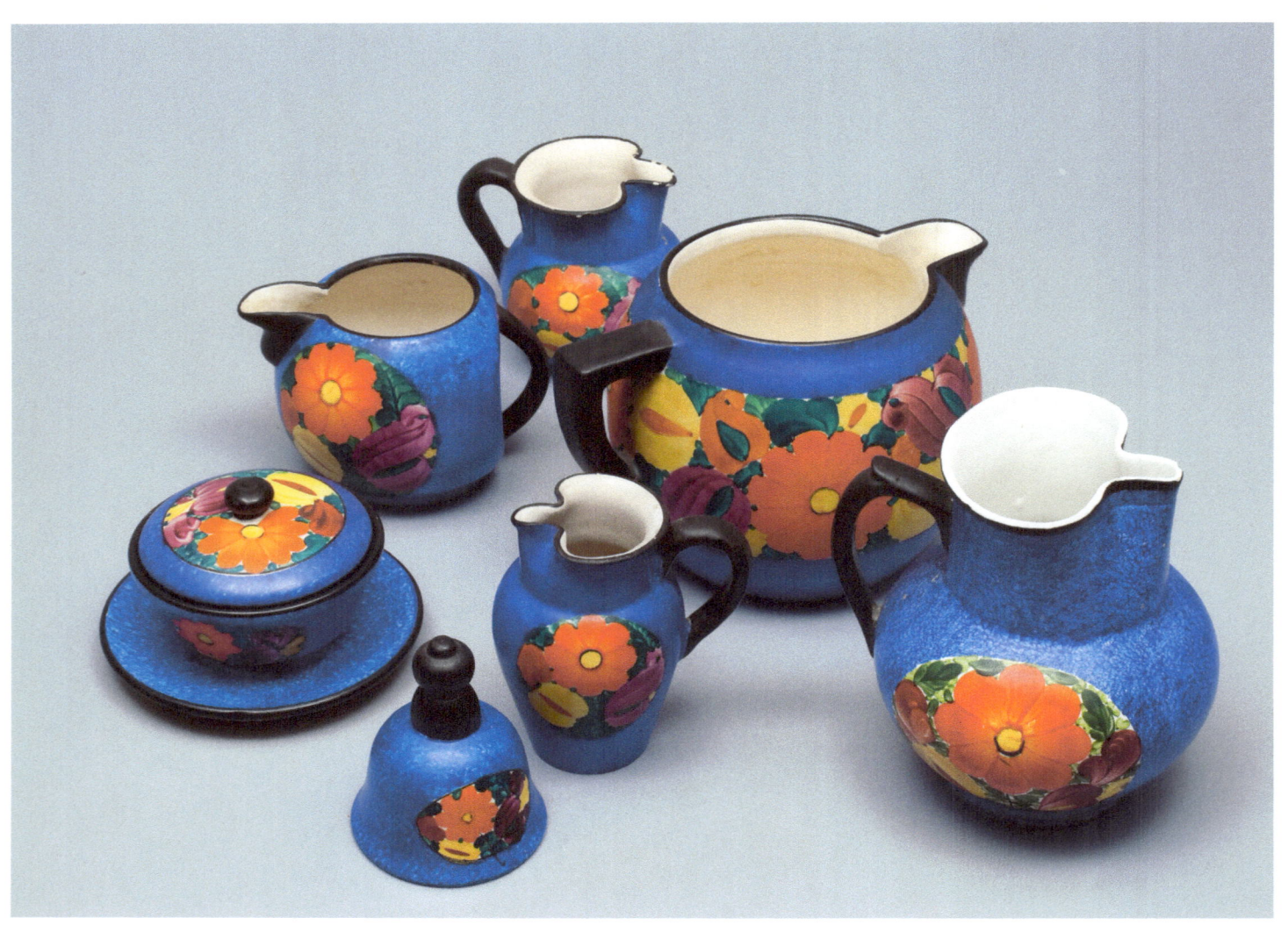

Blue ensemble

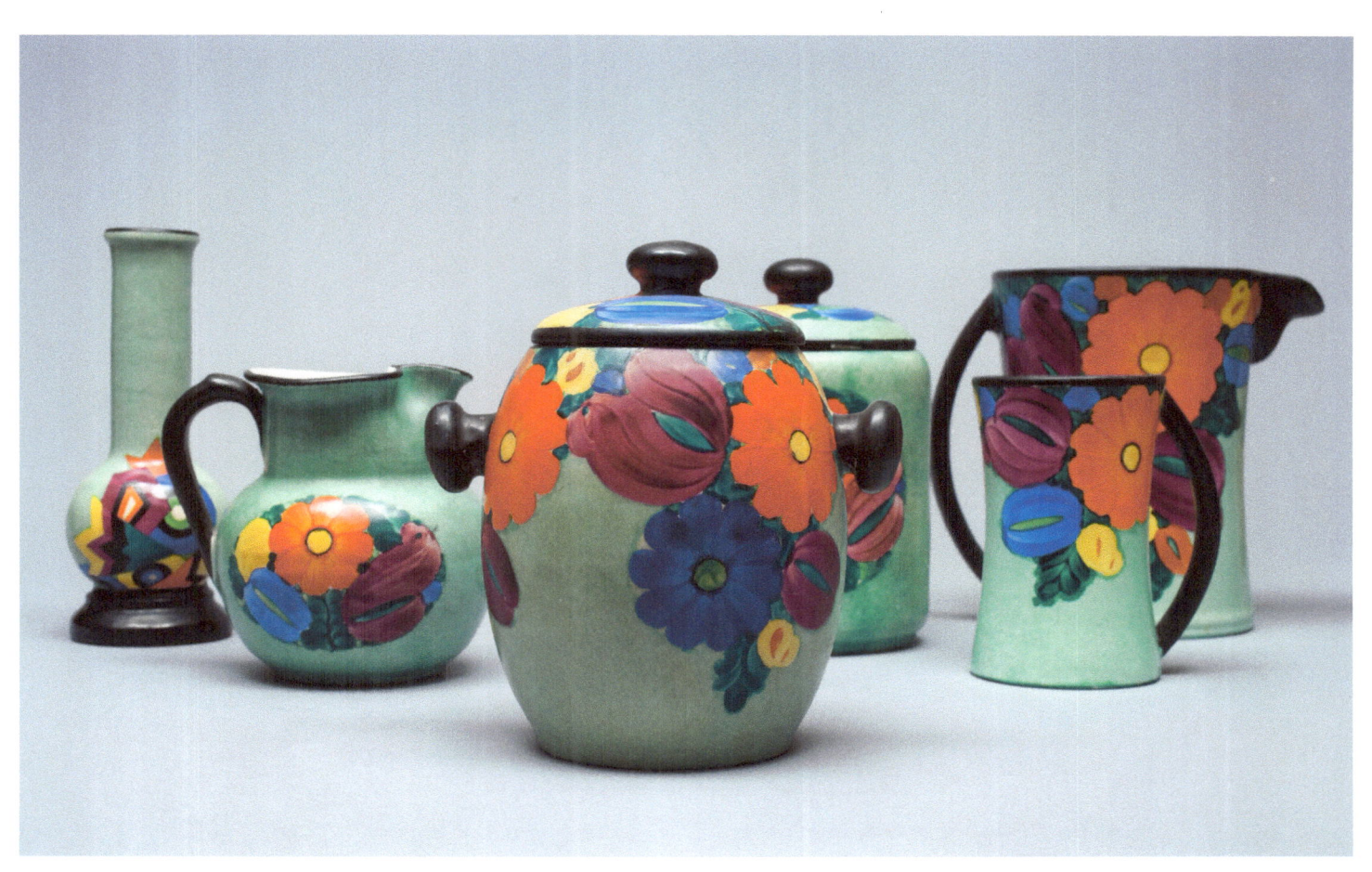

Green ensemble

Additional Mrazek Patterns

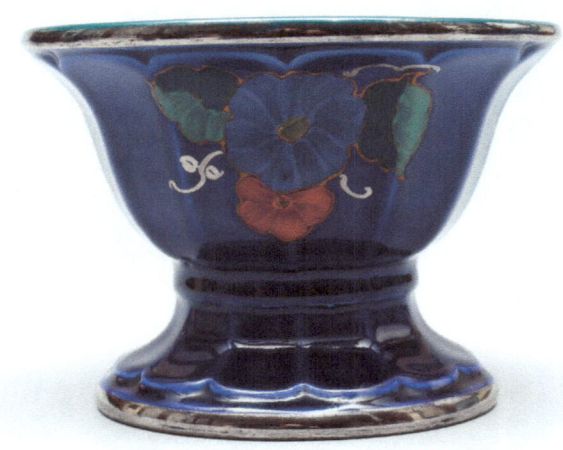

Cobalt bowl
H 5" W 6"

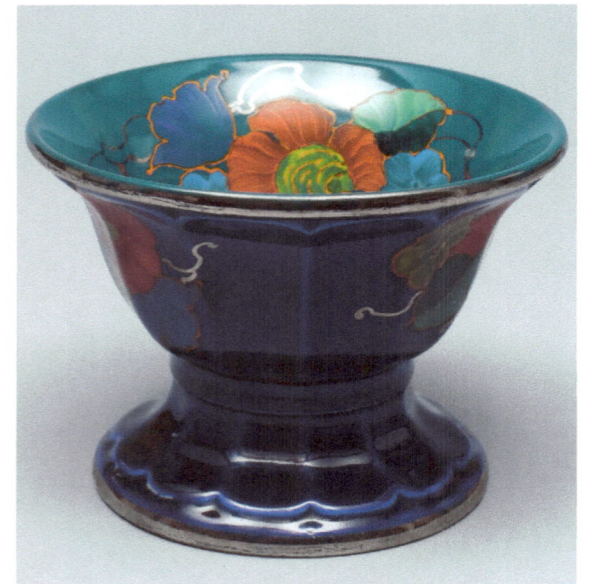

Cobalt bowl

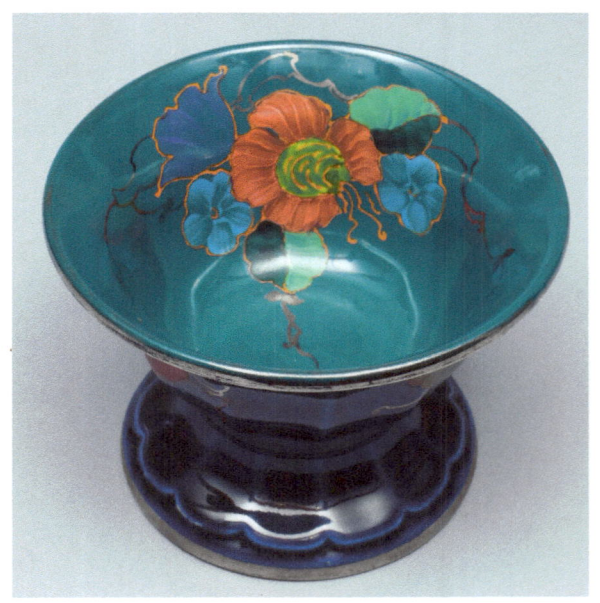

Cobalt bowl

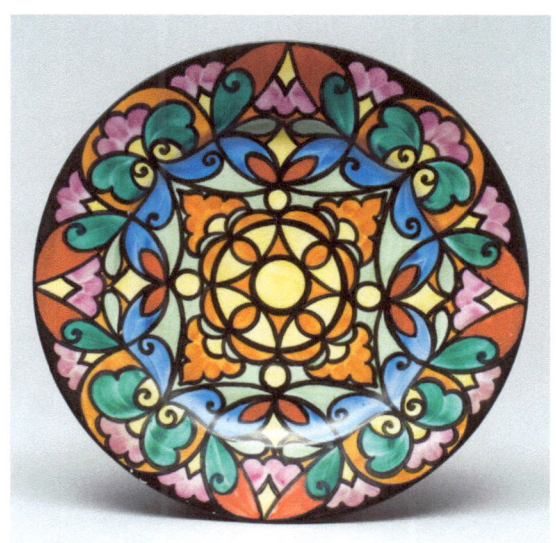

***Stained glass serving plate
12" diameter***

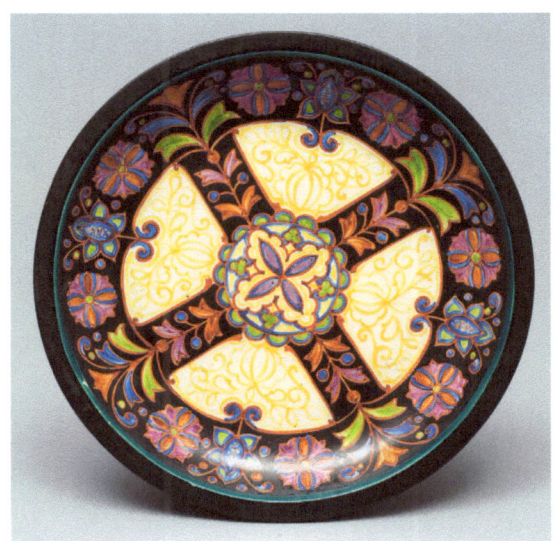

***Stained glass serving plate
11" diameter***

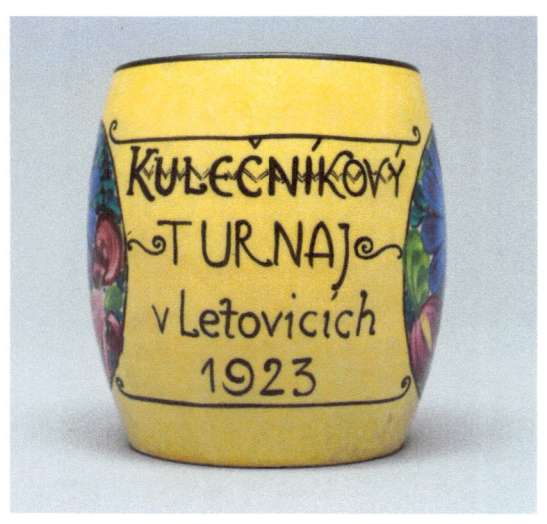

Yellow commemorative mug
H 4 ½" D 4"

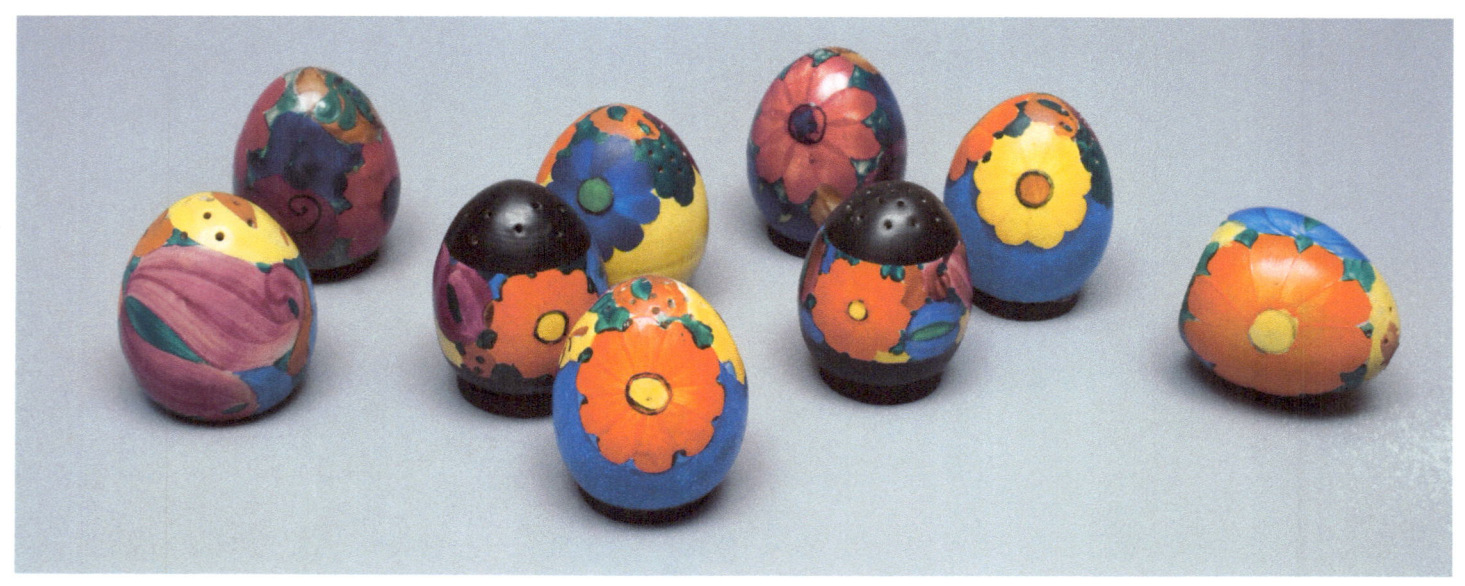

Egg-shaped salt shakers
H 3" W 2"

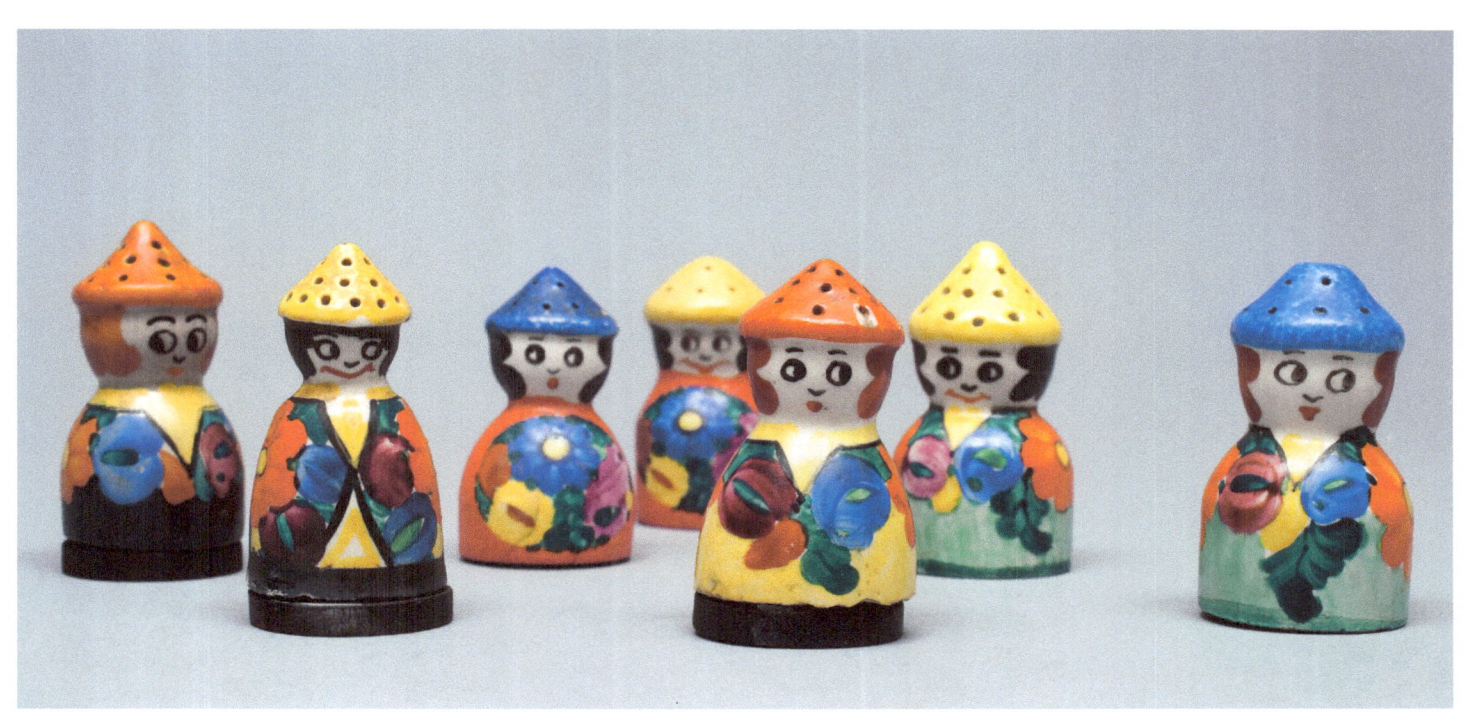

Figured salt shakers
H 3" W 1 ½"

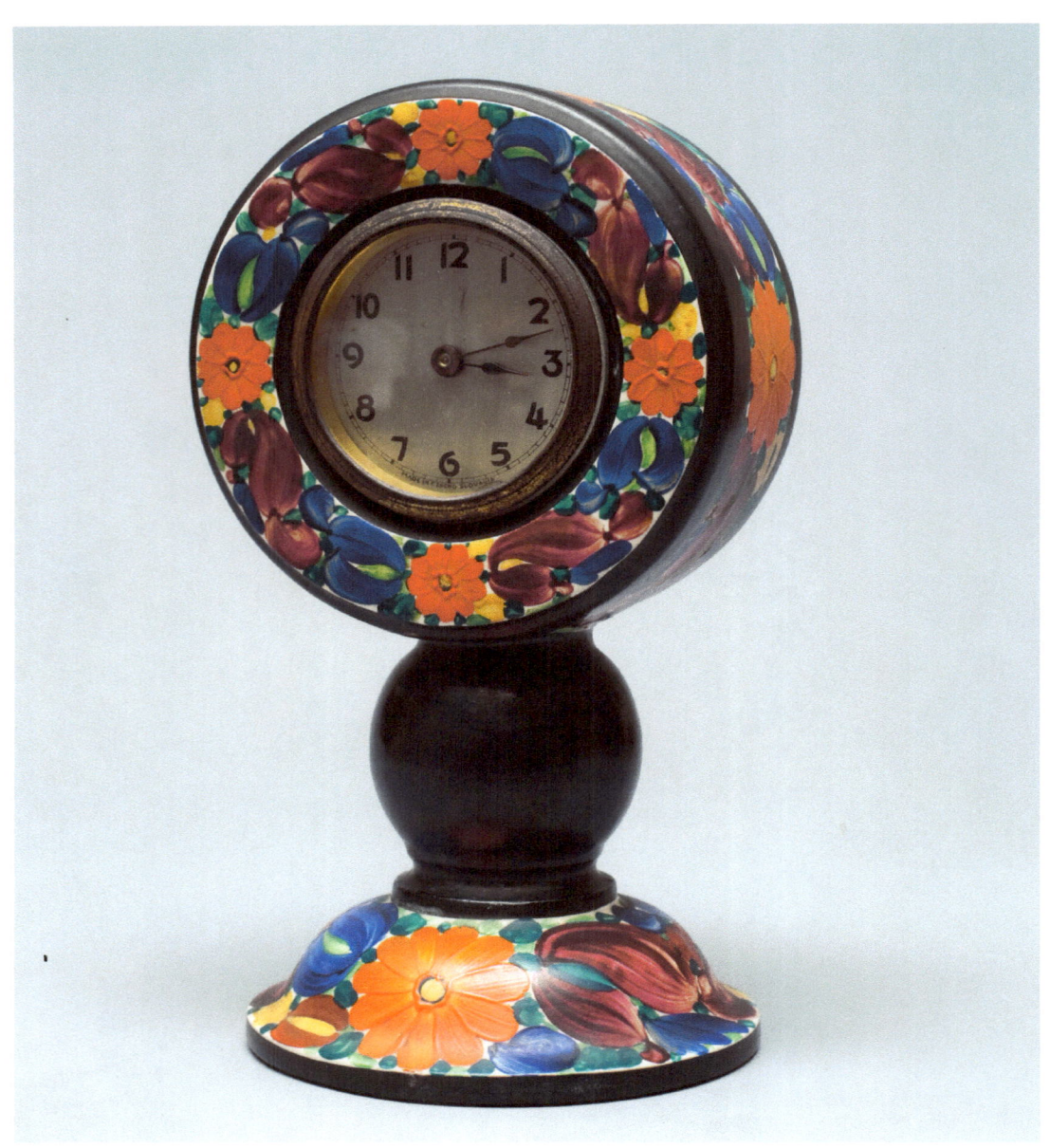

Mrazek clock
H 10" W 6"

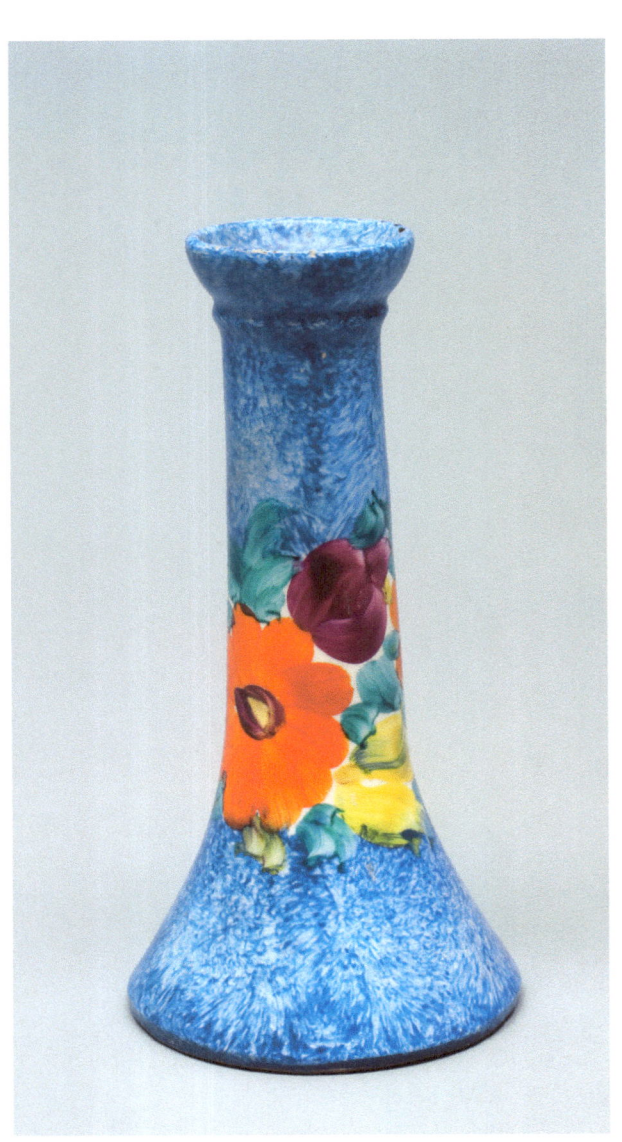

Sponge blue vase
H 8" W 4"

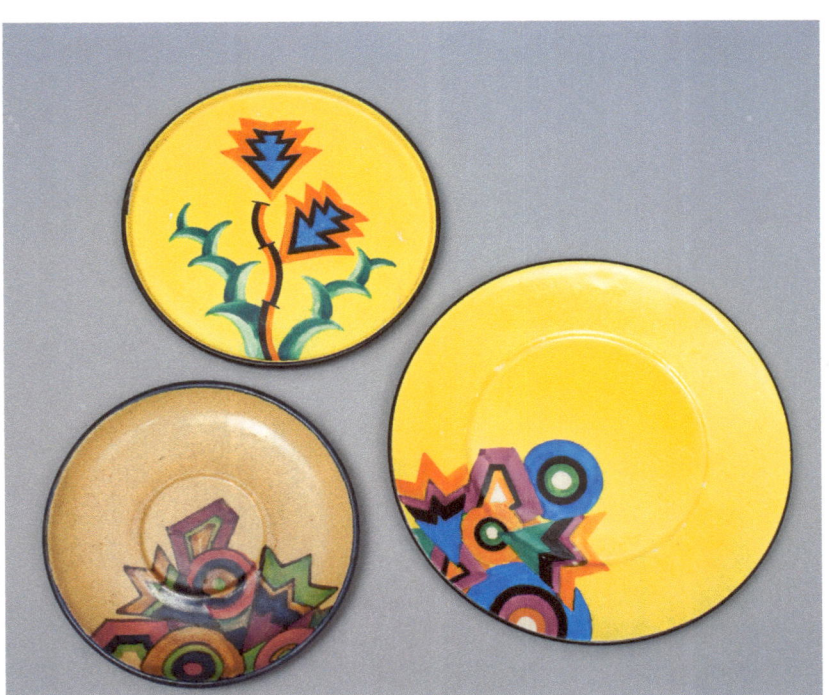

Three Cubist plates
(Right plate) 8" diameter

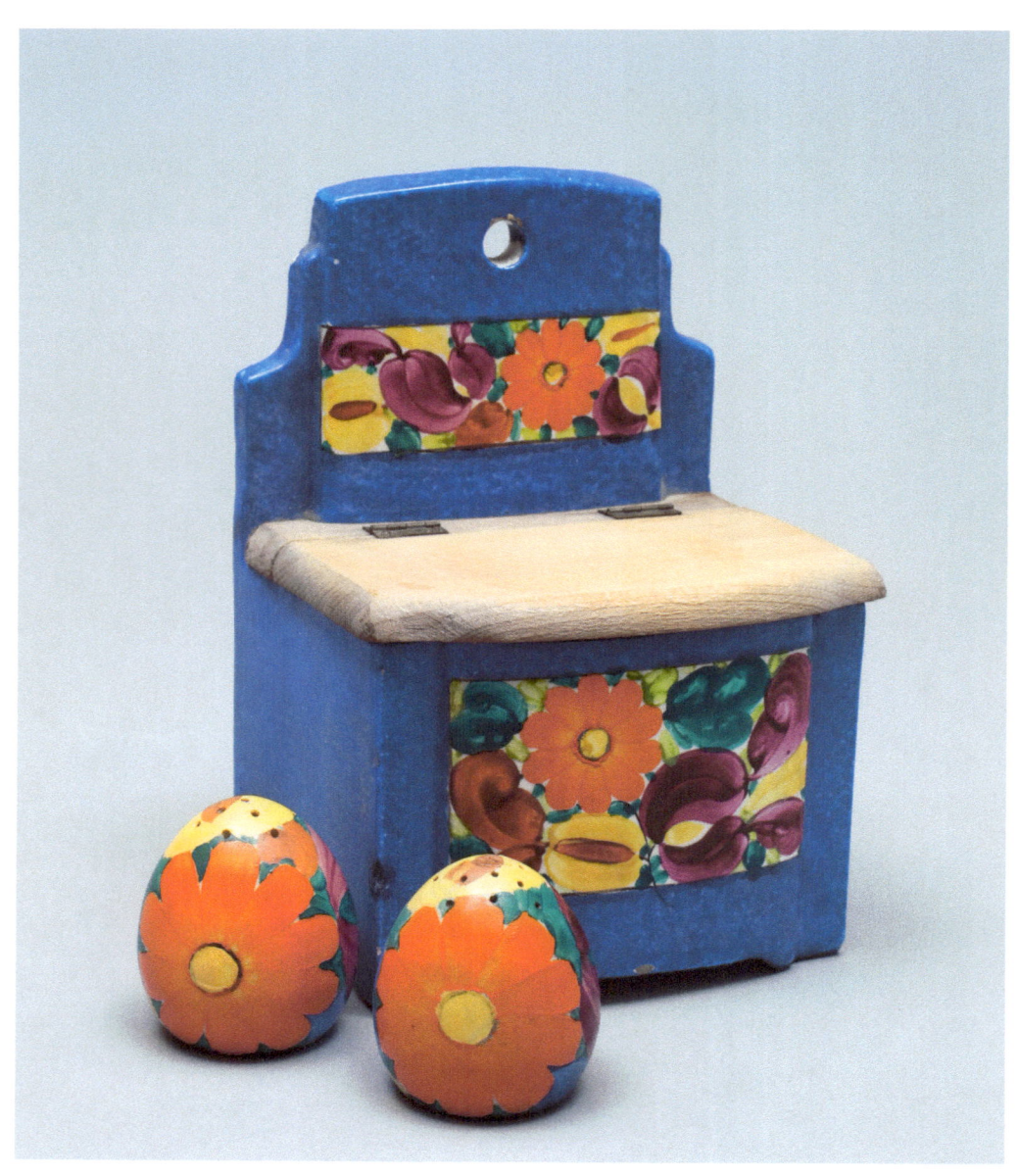

Condiment box and shakers
(Box) H 8" W 5"

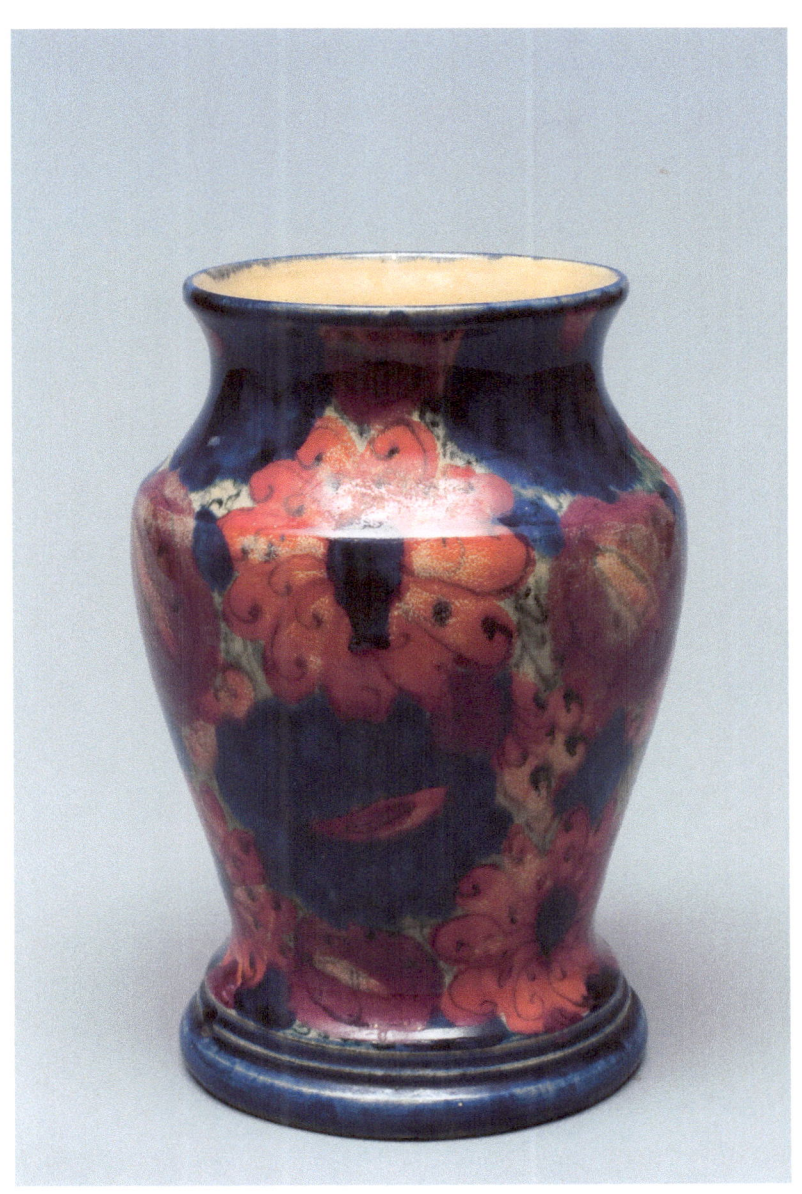

Mulberry vase
H 9 ½" W 7"

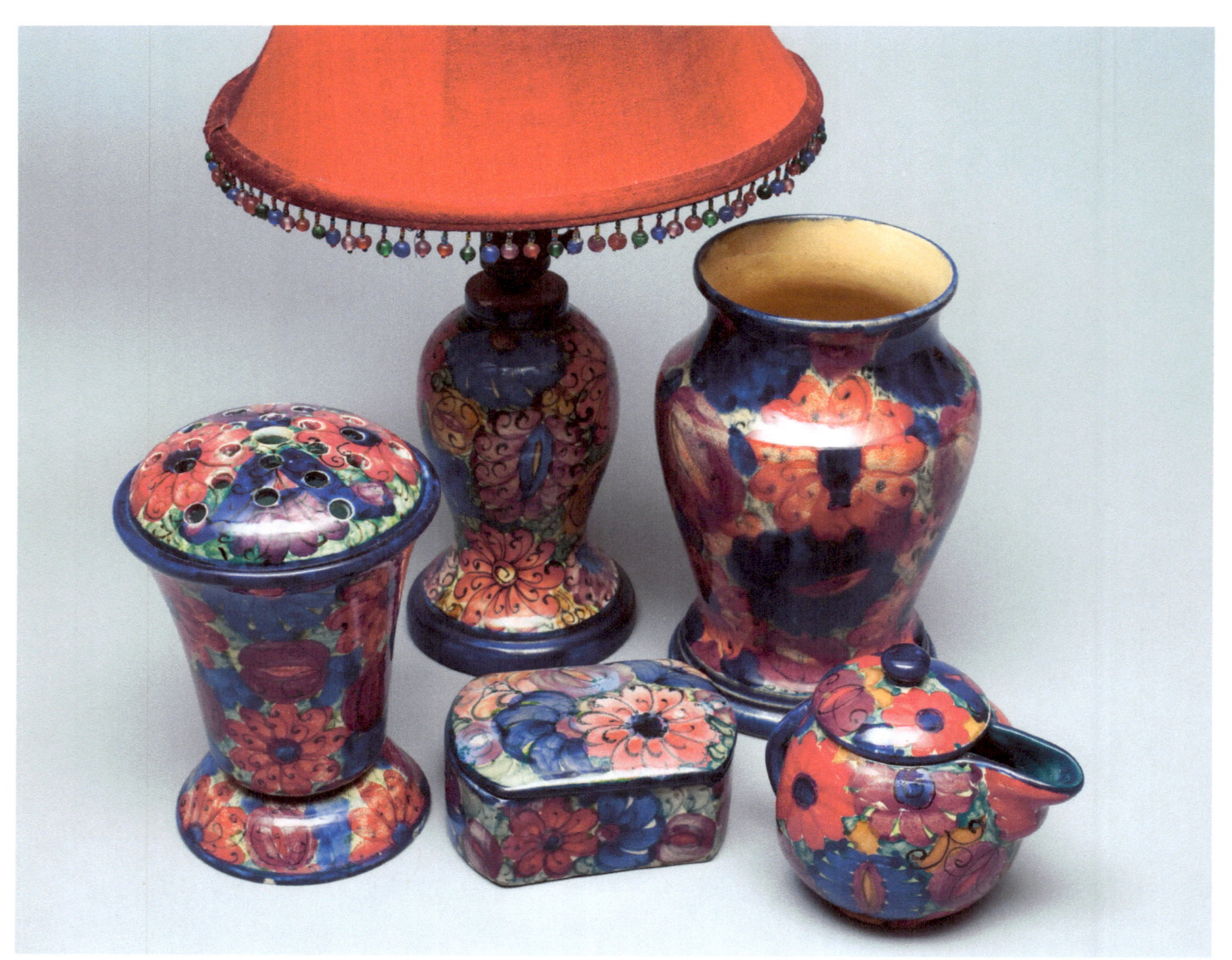

Mulberry ensemble

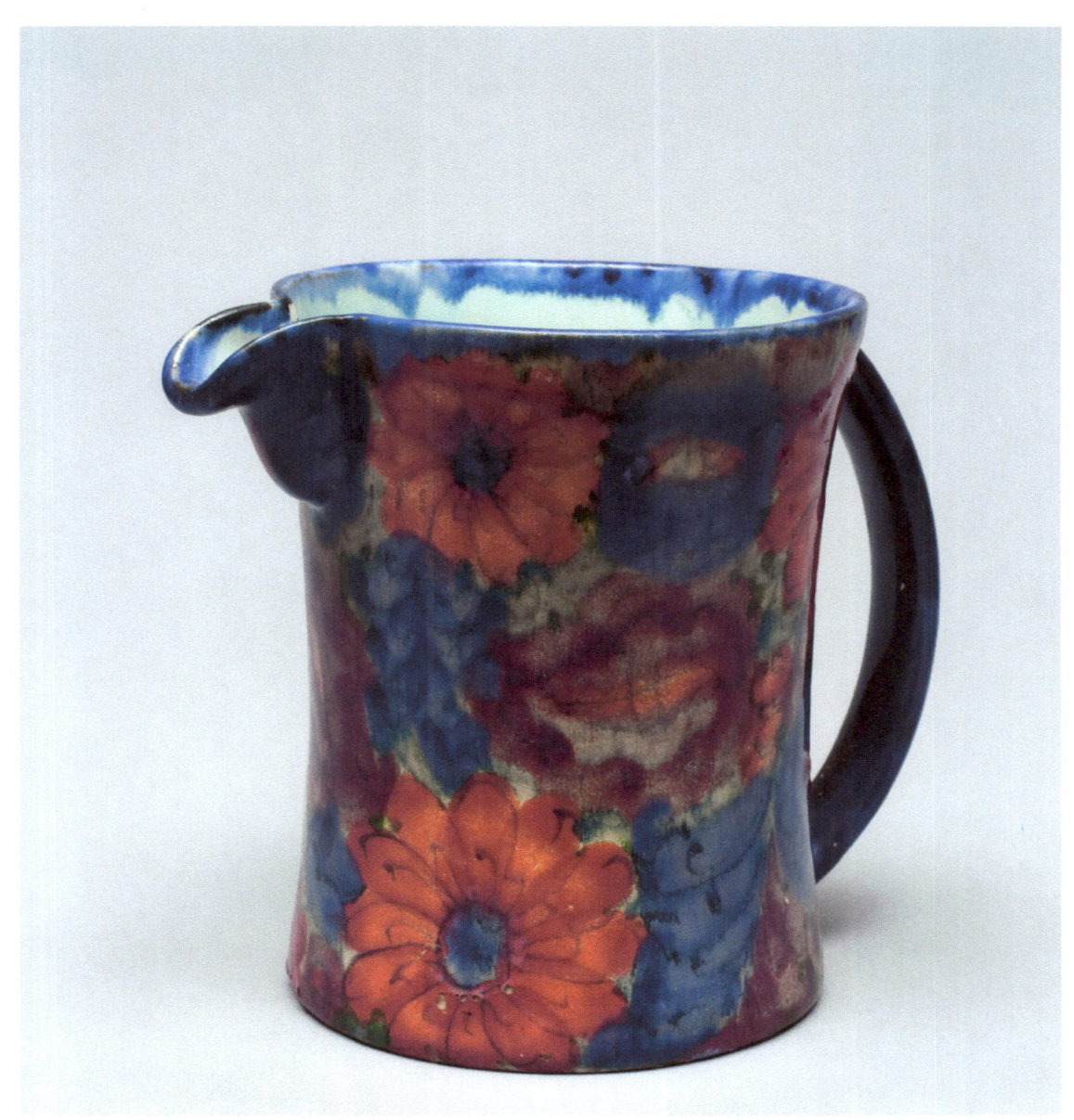

Mulberry Pitcher
H 7" W 7"

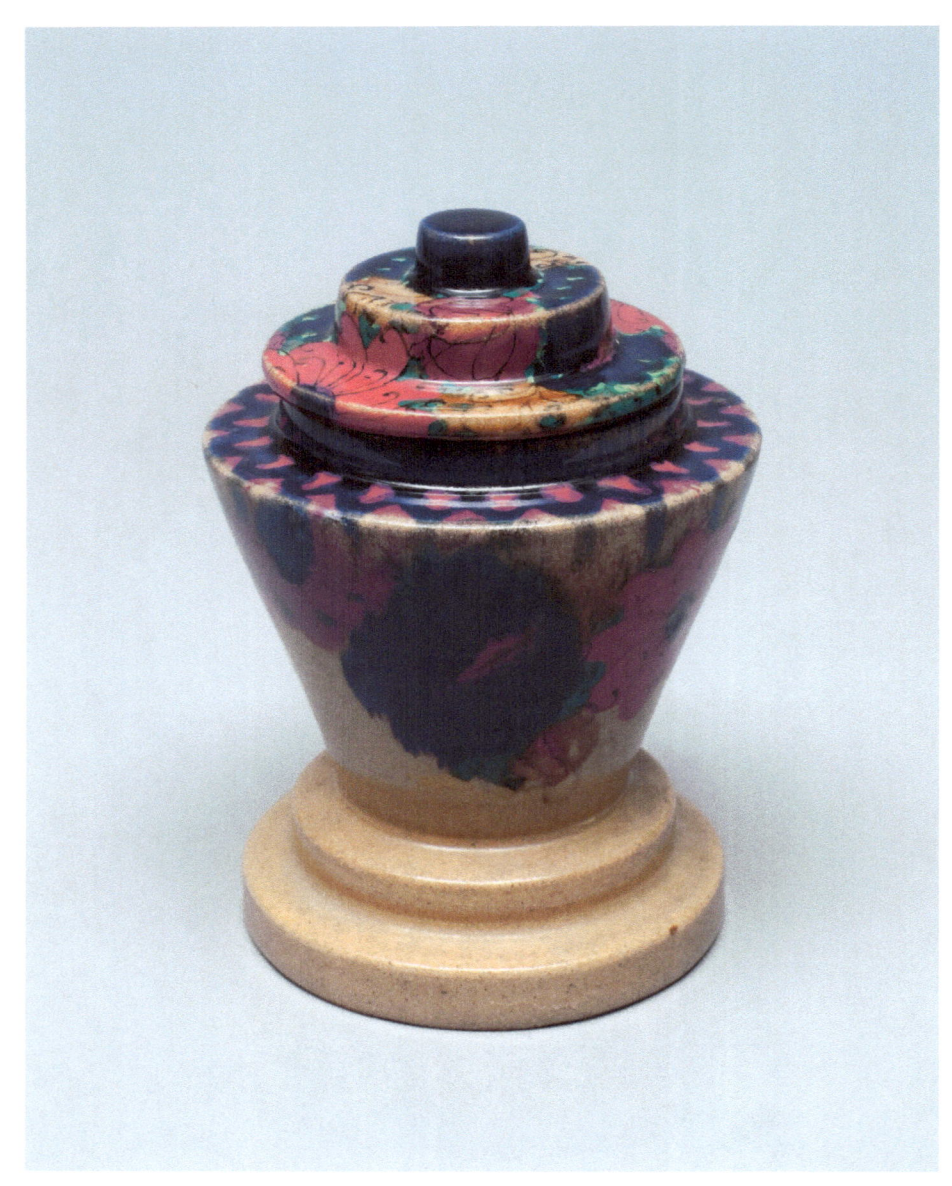

Mulberry Humidor
H 7" W 5"

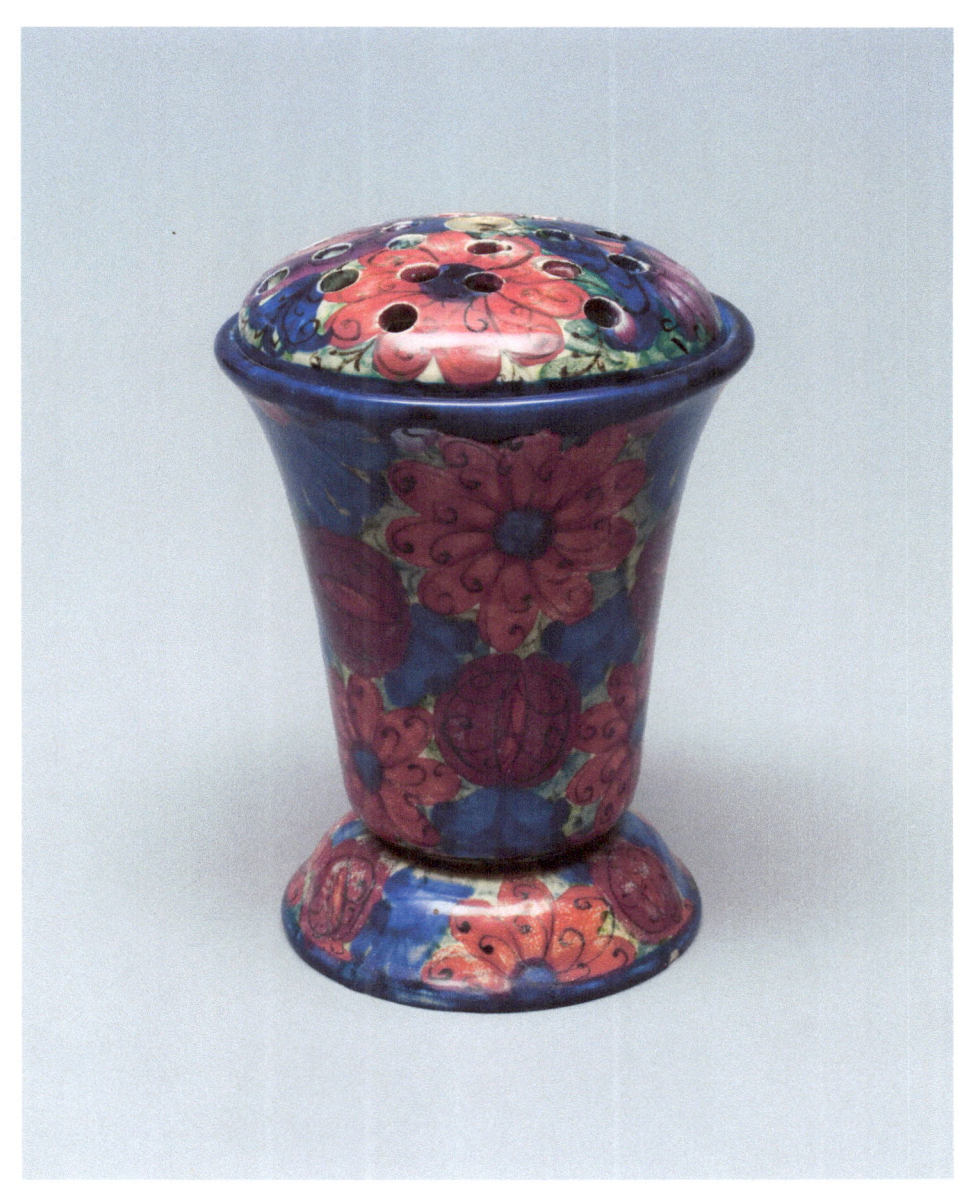

Mulberry Vase with lid
H 8" W 6"

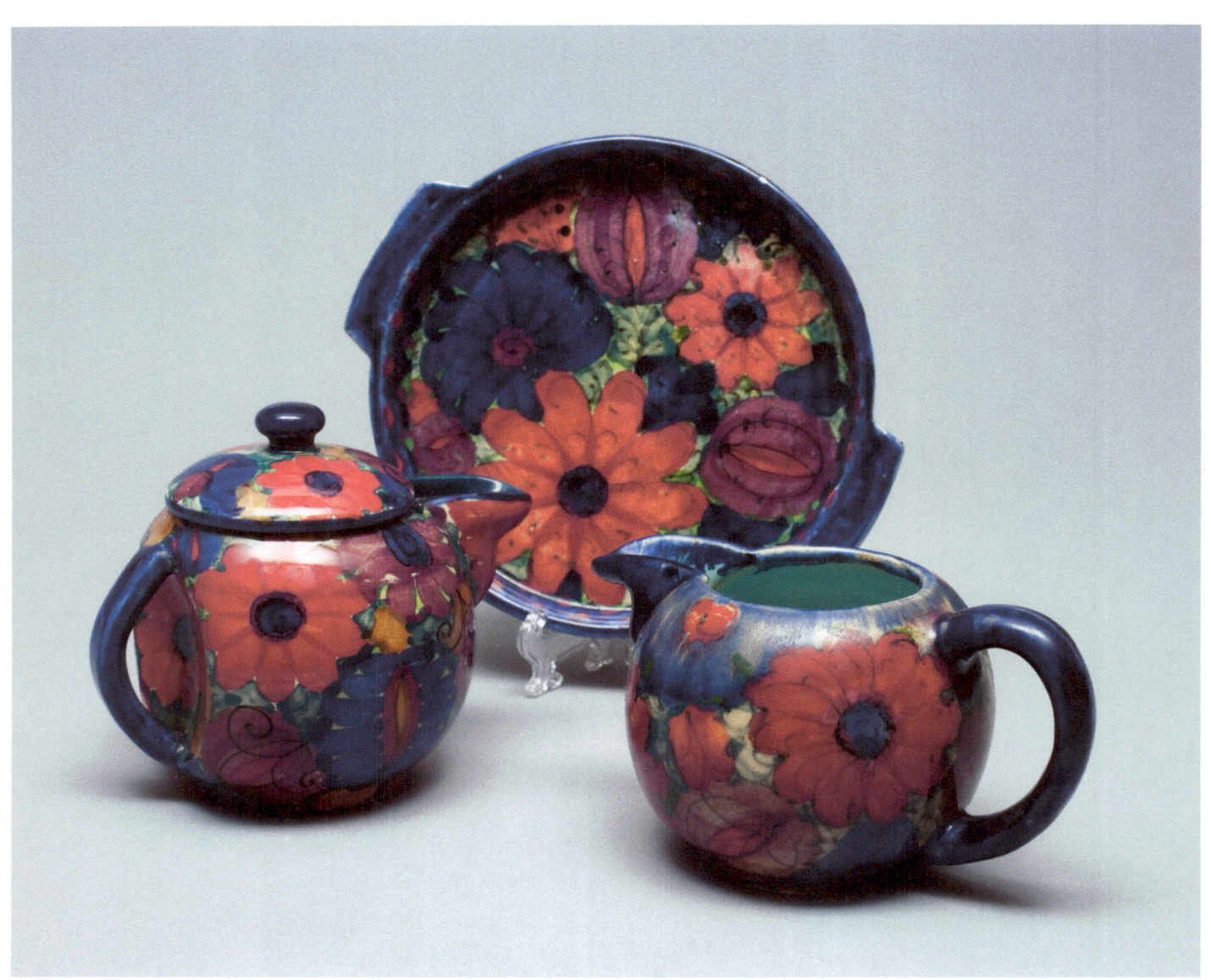

Teapot, pitcher, dish

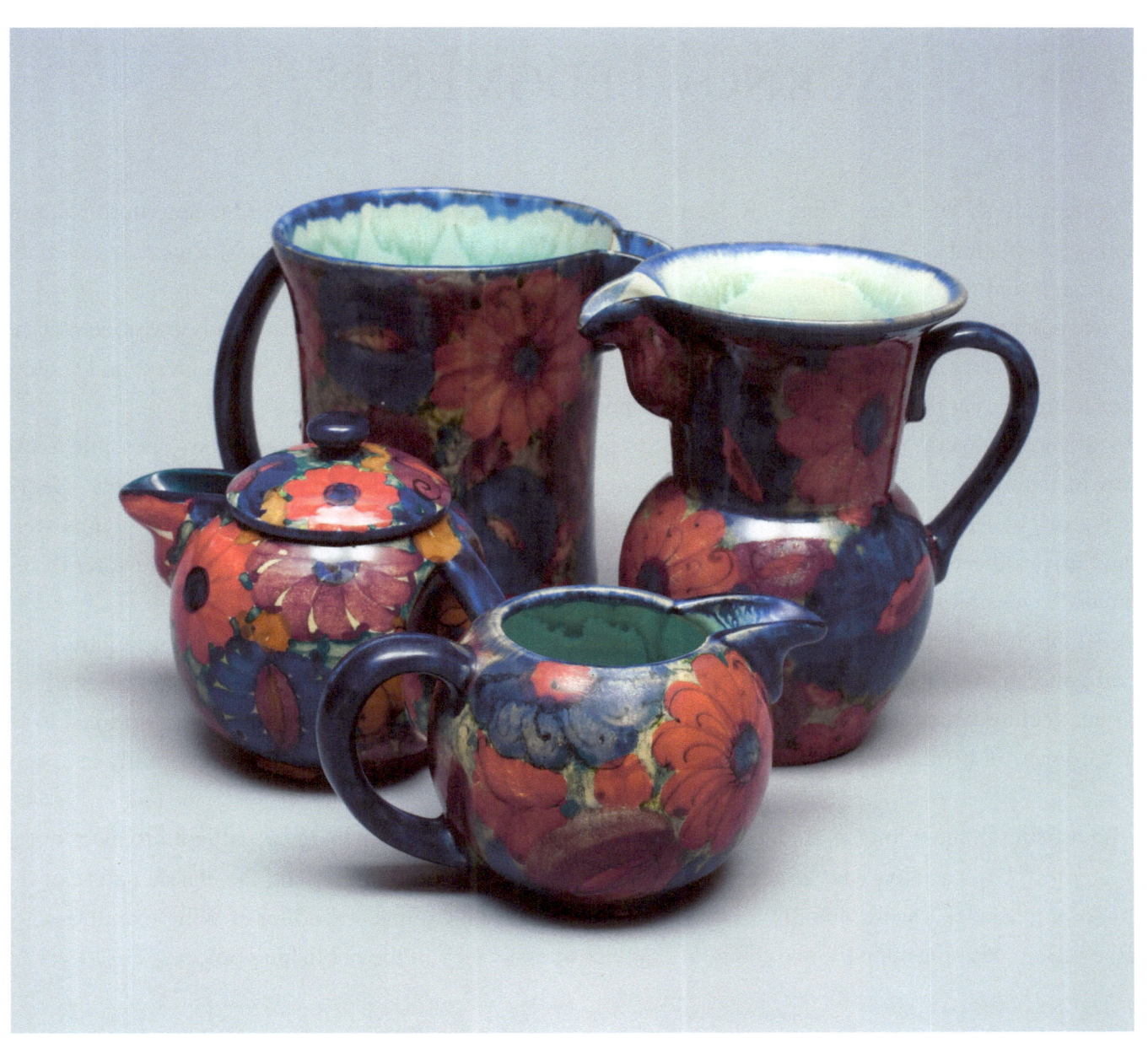

Four Serving Pieces

ACKNOWLEDGMENTS

I regret that my late father, Harold R. Mrazek, did not live to see the final result of his long-nurtured goal to pay homage to his father, Joseph Mrazek. In the years before his death in 2008, Harold Mrazek completed the original research that went into writing this book

I owe a debt of gratitude to my late former wife, Catherine S. Mrazek, who was deeply passionate about Joseph Mrazek's pottery, and long before the Internet used her ingenuity and perseverance to locate and acquire rare pieces from all over the country. Many of them appear in these pages.

In attempting to craft a book that does justice to the life and work of Joseph Mrazek, it was possible to use only a few of the hundreds of photographs and documents that highlighted his many accomplishments. Sadly, many of the original photographs from ninety-year old pottery catalogues and numerous family albums were faded, stained, or otherwise damaged. I am grateful to Ithacan Jeff Foote, who is a very talented restorer of old photographs, for his ability to bring them alive again.

As stunningly vibrant as Joseph Mrazek's pottery remains today (and much of it has been in family use for several generations), a master photographer was needed to capture the quality of the selected pieces from our family collection which were included in the pages of this book. Fellow Ithacan Gary Hodges proved to be truly extraordinary in his flair for lighting and photographing each piece, for which the Mrazek family is deeply grateful.

The artistic director for this undertaking was my good friend Ken Vineberg, a brilliant architect and a man of many gifts. It was Ken who arranged the settings, and helped me to understand the classic nature of the origins of Joseph Mrazek's work. Finally, I would like to thank David Collins, my editor at WingSpan Press, for his creative vision, ongoing support, and thoughtful advice at every step in the publishing process.

THE AUTHORS

Robert J. Mrazek is an award-winning author and novelist. From 1983-1993, he was a member of the United States Congress, where he authored the Amerasian Homecoming Act, which brought home the children of American military personnel from Vietnam, and the law that saved the endangered Manassas Civil War battlefield in Virginia. He also sponsored the legislation that granted most favored nation status to Czechoslovakia after it secured its freedom from the Soviet Union. Since retiring from Congress, Mrazek has published three critically-acclaimed novels including *Stonewall's Gold,* which won the 2000 Michael Shaara Prize for the best Civil War novel of the year. His latest book, the non-fiction *A Dawn Like Thunder: The True Story of Torpedo Suadron Eight,* was published by Little, Brown & Co. in 2009, and was a main selection of the Military and History Book Clubs. His work has been published in fourteen countries.

Harold R. Mrazek was born in New York in 1919, and educated in the United States as well as the former Czechoslovakia. Fluent in four languages, he was recruited during World War II to serve in the Office of Strategic Services (OSS), the predecessor to the Central Intelligence Agency. After the war, he worked for the Grumman Aerospace Corporation, first as an engineer, and later as a corporate executive. During his more than thirty years at Grumman, he felt particularly honored to have been part of the team that helped develop the Lunar Expeditionary Module (LEM), which carried American astronauts to the surface of the moon. An artist at heart, he was deeply proud of his Czech heritage, and spent many years researching and writing both the story of his father's life, as well as the exploits of the illustrious Czech Legion, in which several of his uncles served during the campaign against the Red Army in Russia at the end of the First World War.

www.ingramcontent.com/pod-product-compliance
Lightning Source LLC
Chambersburg PA
CBHW051022180526
45172CB00002B/436